IMAGES
of America

FRANKLIN COUNTY

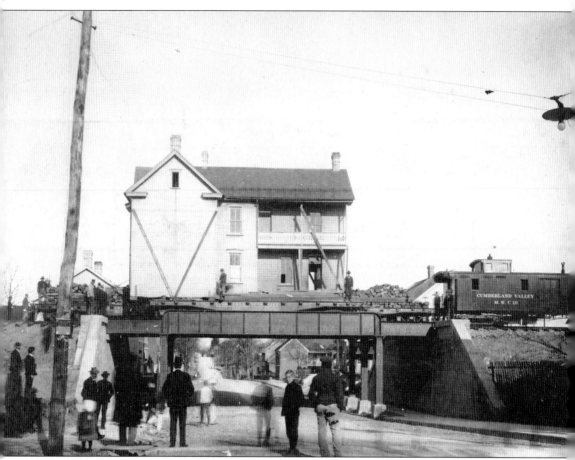

A Cumberland Valley Railroad maintenance crew moves a house across the high line in the north end of Greencastle. Greencastle's double-track high line was constructed from 1906 to 1908 and routed freight and passengers from the old route along Carlisle Street through the square to an elevated rail line west of Jefferson Street.

On the cover: The market house, located at the corner of Second and Queen Streets in Chambersburg, was built by Henry Winemiller in 1830 and later converted into Chambersburg borough offices and the police station. The four-faced town clock in the cupola was added in 1831 and cost $750. In this 1934 photograph, borough employees and the Chambersburg Police Department gather in front of the market house around the traffic light. The original market house was located in the square and was the site of fairs and festivities. (Courtesy of Maurice Leonard Marotte III.)

IMAGES
of America

FRANKLIN COUNTY

Maurice Leonard Marotte III
and Janet Kay Pollard

ARCADIA
PUBLISHING

Published by Arcadia Publishing
Charleston SC, Chicago IL, Portsmouth NH, San Francisco CA

Printed in the United States of America

Library of Congress Catalog Card Number: 2007926416

For all general information contact Arcadia Publishing at:
Telephone 843-853-2070
Fax 843-853-0044
E-mail sales@arcadiapublishing.com
For customer service and orders:
Toll-Free 1-888-313-2665

Visit us on the Internet at www.arcadiapublishing.com

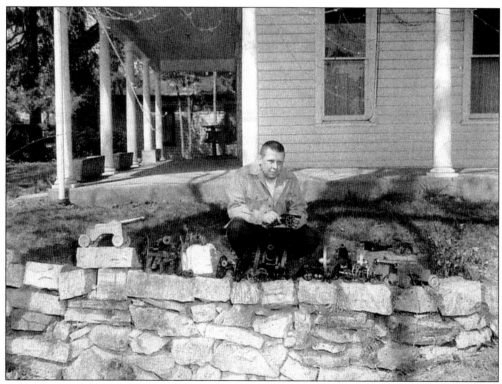

Maurice Leonard "Mike" Marotte III dedicates this book in honor of his father, M. L. "Mike" Marotte Jr., who loved history and antiques and took the time to teach the value and importance of the history of Franklin County. Additionally, Maurice would like to dedicate this work to the rich historic past and bright future of Franklin County. This photograph depicts M. L. "Mike" Marotte Jr. at Stoufferstown with his black powder cannon collection in 1960.

CONTENTS

ACKNOWLEDGMENTS

Whether the proverbial statement "a picture is worth a thousand words" was coined from a Chinese proverb, Napoleon Bonaparte, or an advertising entrepreneur, it remains true. A community with an Arcadia Publishing Images of America book has a collection of photographs and facts that help the community story to survive a little longer. It is a gift to help us all "remember when."

The photographs and original images of *Franklin County* are from the extraordinary collection of Maurice Leonard "Mike" Marotte III. Thank you, Mike, for teaming up again.

A few images of St. Thomas before and after the widening of Route 30 in the 1930s were shared by Mary Fish. Thank you, Mary.

A special thank-you goes to Will Pananes for helping to fill in last-minute spots with photographs and etchings, for sharing his knowledge, and for his support in completing the project. Thank you, Will. A personal thank-you goes to my children—Christina, Jonathan, Sarah, and Matthew—for their support and understanding of missed dinners, telephone calls, and so on.

Books like *Franklin County* would not be possible without photographers, archivists, and recorders. *History of Franklin County, 1887* was a frequent source of facts. One final thank-you goes to all who participate in capturing and preserving history and to the organizations and institutions like Allison Antrim Museum, Chambersburg Heritage Center, Conococheague Institute, the historical societies of Franklin County and Shippensburg, and Renfrew Museum and Institute that hold and give access to Franklin County's history, artifacts, and stories.

—Janet Kay Pollard

INTRODUCTION

Pennsylvania was founded by a man who was expelled from Oxford for his nonconformity to established religious practices, put out of his home by his father, and imprisoned for seven months in the Tower of London for espousing his religious beliefs. William Penn exemplifies the fiber of the men who settled Pennsylvania and Franklin County. Seeking freedom and opportunity, these men were drawn to the life that the land could offer to sustain them physically and spiritually.

Franklin County, as part of the Cumberland Valley and the Great Valley, offered the bountiful resources of water and timber and a mixture of flora and fauna. Many original accounts written by settlers to the area recognize the beauty of the land. These settlers chose Franklin County because it was reminiscent of the geography of their former homes.

The majority of the first settlers were Scotch-Irish. The hardworking nature and perseverance of the Scotch-Irish helped the county to grow. German immigrants also settled in the area and brought a commitment to work. Grateful to have a place to make into a home, these settlers built the foundation of Franklin County.

By the time Franklin County was formed from Cumberland County, its population was about 13,000. At the time of the Civil War, it had grown to more than 43,000, and by 1900, it was nearly 55,000. Good access to transportation helped fuel the county's manufacturing capabilities. Initially the road system in the county attracted the railroad, and now the rail system spurred upgrades to roads. America had moved into the second wave of the Industrial Revolution, and Franklin County was keeping pace.

Franklin County's story is America's story. The events and experiences shaping Franklin County—the frontier, the Civil War, the development of rail and industry—shaped America. The communities of Franklin County embrace their history and take pride in the challenges and the contributions that made a difference to Franklin County and America. The fiber of Franklin County's heritage continues to be the foundation of Franklin County's future.

One

FOUNDING

FRANKLIN COUNTY

The Chambers brothers were among the first frontiersmen to move into the land that would be Franklin County. Emigrating from County Antrim, Ireland, and initially settling along the Susquehanna River, the four brothers moved farther south in 1730. One settled at the Great Spring, near Newville, and another at Middle Spring, near Shippensburg. One returned to manage the settlement along the Susquehanna, and Benjamin Chambers settled at the Falling Spring, the beginning of Chambersburg.

About the same time on the west bank of the Conococheague Creek, William McDowell established a settlement in Peter's Township, and James Black settled Black's Town, which became Mercersburg.

Around 1735, in Antrim Township, James Johnston settled a tract of land. Path Valley had early settlements also. In 1737, Samuel Bechtel had a warrant for 176 acres in Fannett Township, and Thomas Doyle a warrant for 530 acres. At this time, all the established areas of Franklin County were known as the Conococheague Settlement.

Over the next four decades, more settlers were drawn to the fertile lands and flowing waters of Franklin County. Franklin County grew and prospered. Its citizens supported the Revolutionary War and welcomed the liberties of independence. On September 9, 1784, the Pennsylvania legislature apportioned Franklin County from Cumberland County and named Chambers' Town—later Chambersburg—as the county seat of justice. The commonwealth named the county to honor the remarkable citizen, sage, and philosopher Benjamin Franklin.

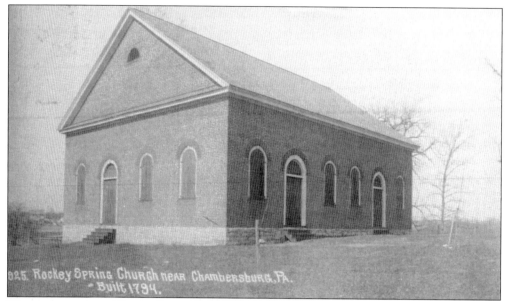

The congregation of Rocky Spring Presbyterian Church was organized in 1738, and the first pastor was Rev. Thomas Craighead. The first church was a one-and-a-half-story log structure. The Rocky Spring church in this photograph is the second edifice, a brick structure, built in 1794 by Walter Beatty. Rev. John Craighead served as pastor in the new church. He was known as the "fighting chaplain" because he led his men as captain in the Revolutionary War and ministered to them as pastor in the camp.

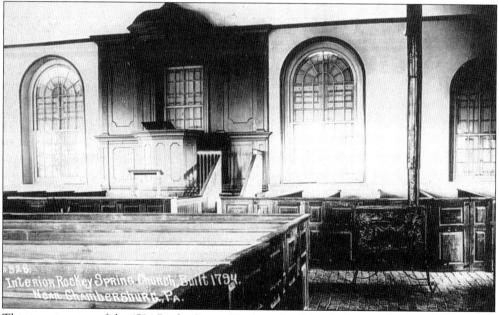

This interior view of the 1794 Rocky Spring Presbyterian Church features the hand-planed and unpainted oak pews and pulpit. The interior, a single 50-foot-by-60-foot room, has two 10-plate stoves that were vented into the garret where the smoke could escape without a chimney. The church no longer has an active congregation but opens yearly for a special memorial service. The church was added to the National Register of Historic Places in 1994.

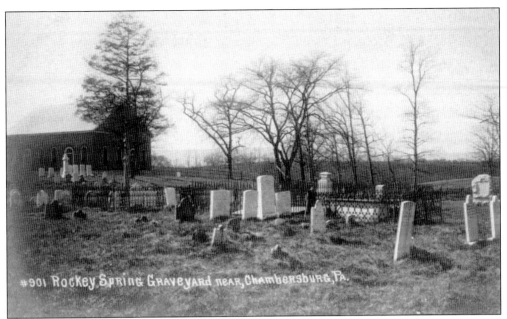

The Rocky Spring Presbyterian Church graveyard has a plaque that names the church members who served during the Revolutionary War. Sarah Wilson, who was the major benefactor of Wilson College, is buried in the graveyard.

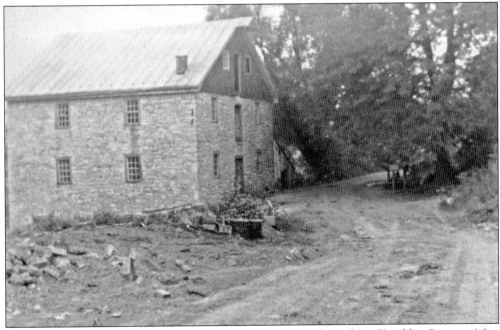

With the availability of potent waterpower, mills sprang up throughout Franklin County. After years of active use, the Rocky Spring Mill, shown around 1900, had fallen into disrepair. The mill took the name of the nearby Rocky Spring where waters flowed through limestone rock.

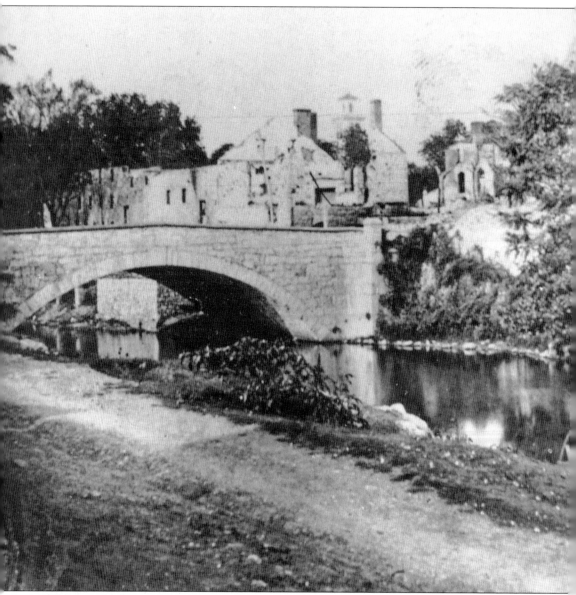

The stone bridge on King Street in Chambersburg was built in 1828 by Silas Harry. Harry also constructed the Masonic temple on Second Street in Chambersburg. This view looks northeast shortly after the Confederate burning of Chambersburg in 1864.

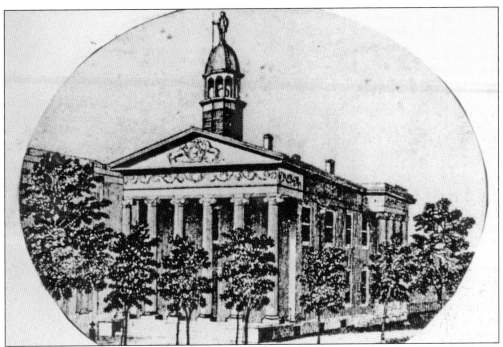

An old postcard view of the second courthouse shows Benjamin Franklin atop the cupola. This courthouse was built in 1842 on land that Benjamin Chambers deeded to the county for $26.66 2/3. The second courthouse was built on the same land by carpenter Philip Miterhouse and mason Silas Harry. Confederate troops led by Gen. John McCausland burned the courthouse and the buildings in the core of Chambersburg on July 30, 1864.

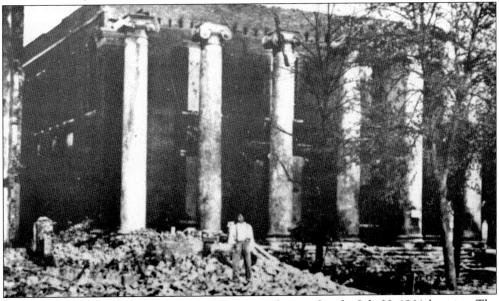

This photograph features the Franklin County courthouse after the July 30, 1864, burning. The burning of Chambersburg was done in retribution for the burning in the Shenandoah Valley. Squadrons of Confederate troops fired every other house, and the center of town was destroyed in about two hours.

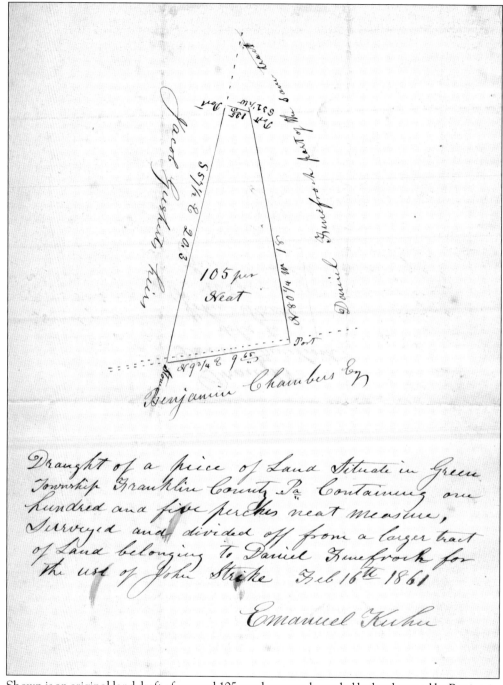

Draught of a piece of Land Situate in Green Township Franklin County Pa Containing one hundred and five perches neat measure, Surveyed and divided off from a larger tract of Land belonging to Daniel Finefrock for the use of John Strike Feb 16th 1861

Emanuel Kuhn

Shown is an original land draft of a parcel 105 perches neat, bounded by land owned by Benjamin Chambers, Daniel Finefrock, and the heirs of Jacob Gushert. A perch is the same as a rod and is 16.5 feet. The tract is in Greene Township.

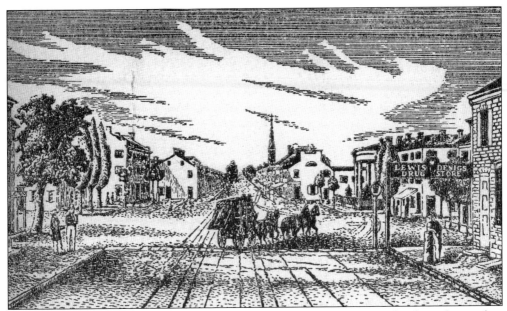

This etching, reproduced on a postcard, shows a rendering of the Chambersburg diamond in 1840. The stagecoach is heading west. In the background, note the Zion Reformed Church's spire, which was inspired by the designs of the British architect Christopher Wren. In 1877, as a young man, W. W. Denslow, original illustrator of *The Wonderful Wizard of Oz*, climbed the spire and sketched a panoramic view of Chambersburg.

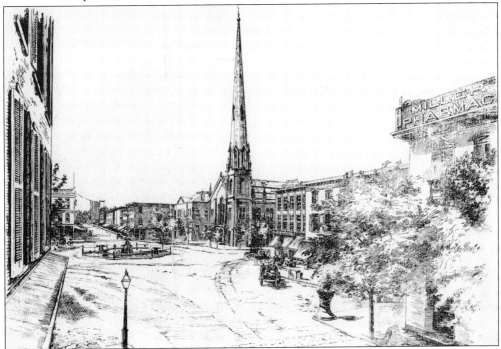

This etching shows a view of the square and South Main Street of Chambersburg in 1886. The 186-foot spire of Central Presbyterian Church is in the foreground. Central Presbyterian Church was erected in 1869.

CHAMBERSBURG & BEDFORD TURNPIKE ROAD
COMPANY. No. 78

This is to certify, that *Jacob Bennett Esqr* holds *fifteen* ares of stock in the Chambersburg and Bedford Turnpike Company, of fifty dollars ch, upon which *375* dollars and ~~cents~~ have been paid ; transfer le in person or by attorney, in presence of the President or Treasurer of said Company

IN TESTIMONY WHEREOF, we have hereto set our hands, and affixed our common seal, the *Fourth* day of *Janua* A. D. 1817

J. Holliday Presiden

Shown is an 1817 stock certificate for the Chambersburg and Bedford Turnpike Road Company. The certificate issues 15 shares of stock at $50 each and shows that $375 of the total $750 was paid. The certificate is signed by Chambersburg and Bedford Turnpike Road Company president J. Holliday.

CHAMBERSBURG AND BEDFORD
TURNPIKE ROAD COMPANY.

No. 110

It is hereby Certified, That *R. D. Barclay in trust* entitled to *Fifteen* Shares of the Capital Stock of the Chambersburg and Bedford Turnpike Road Company upon which *Seven hundred & fifty* Dollars have been paid—Transferable on the Books of the Company, in Person or by Attorney, in presence of the President or Treasurer thereof.

Witness the Corporate Seal of the said Company the *twenty second* day of *March* 185

T. B. Kennedy President

N. G. M. Dowell

This 1859 stock certificate of the Chambersburg and Bedford Turnpike Road Company issues 15 shares of stock. The $750 was paid in full. The certificate is signed by Chambersburg and Bedford Turnpike Road Company president T. B. Kennedy, who would later become president of the Cumberland Valley Railroad.

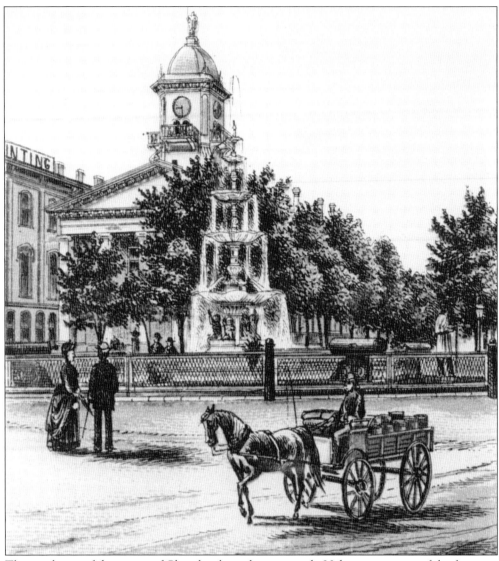

This rendering of the square of Chambersburg shows an early-20th-century view of the fountain and Franklin County courthouse. The fountain was established as a memorial to those who fought and died in the Civil War. Originally the fountain was enclosed by a chain fence.

Two

CHAMBERSBURG, THE COUNTY SEAT

In 1735, Benjamin Chambers and a party of men blazed the first road in the Cumberland Valley. The road was a portion of an effort to connect Harris Ferry (Harrisburg) to the Potomac River. Supplies and goods were shipped on the turnpike from Chambersburg to Baltimore and Chambersburg to Pittsburgh. Inns and taverns, livery stables, wheelwrights, blacksmiths, and a variety of merchants and manufacturers sprang up as Chambersburg became a center of transportation.

By 1780, Chambersburg had its first fire company. The first post office of Franklin County was set up in Chambersburg in June 1790. The *Chambersburg Gazette* was first published in 1793 and retained that name until 1796 when it became the *Franklin Repository*. Chambersburg Grammar School opened in April 1793. Chambersburg Water Works launched operation in 1818, pumping water from the Falling Spring to a cistern and then to town in wooden pipes to 37 subscribers. Operation was suspended in 1823; decades later the town built another waterworks.

By 1837, the Cumberland Valley Railroad was operating in Chambersburg and commenced the town's era as a railroad town. The Chambersburg Gas Works began service in 1856. Chambersburg was a solid town when Confederates attacked Fort Sumter on April 12, 1861.

The Civil War seriously tested Chambersburg's existence, and it was raided first on October 10, 1862, by Maj. Gen. J. E. B. Stuart and 1,800 Confederate troops. The Confederates took horses and ammunition, cut the telegraph wires, burned the railroad's engine house and machine shops, and burned warehouses of ammunition. Gen. Robert E. Lee and 65,000 Confederate soldiers followed in June 1863. Headquartering in Chambersburg, Lee got word of Union troop movements, altered his plans to move troops toward the Susquehanna River, and decided to move east to protect the communication and supply lines of Virginia. The Confederate and Union troops clashed in Gettysburg.

The final assault of the war came on July 30, 1864, when Gen. John McCausland, by order of Gen. Jubal Early, demanded the town pay $100,000 in gold or $500,000 in Yankee currency or Chambersburg would be burned. The great fire destroyed 550 structures valued at $783,000 and left 2,000 people homeless.

Old Flag.

M'CLURE & STONER. CHAMBERSBURG, PA., WEDNESDAY, OCTOBER 17, 1866. VOL. 2.

The Old Flag.

ELECTION NIGHT IN CHAMBERSBURG.—JOYS AND SORROWS OF POLITICS.—The annual re- turn of general election day was this year unusu- al even with fate. It dawned on brighter hopes and witnessed sadder disappointments than al- most any of its predecessors. Both parties saw the morning sun as the sun that shone on the ies of Austerlitz, and with unabated zeal the contending armies fought it out contesting each. The boys had their fun, and their fires, and their apples, and were jolly with the blaze of magnificent bonfires in the even- ing. The doubtful voters were generally run off early and allowed to spend the remnant of day in obscurity, while the leaders looked after more important voters not yet run in and the mill. The Republicans were earn- est and confident, and had the field in the wards before the day was half spent, and Democracy were prepared to yield something ... sanguine figures before the polls closed. ... were still confident. They had the ... Ward sure—so all their managers and ... ectors insisted. Some of their knowing it up to 30, and a few even above that; ... Republicans laid aside their paper calcu- ... and put out their best efforts to carry the ... It was nobly, untiringly fought, and nobly

... the sun was sinking behind the western ... for the first time in the history of elec- ... the votes were all polled. At six o'clock ... ublicans had their work done, and in the ... oxes of Guilford and the two wards there ... six votes wanting or expected half an

managers of both Bureaus were found trying to explain the election to the town pump, and after- wards were engaged in a fierce pugilistic strug- gle with a black lamp-post, which they mistook for a "buck-nigger" trying to get into a front pew in the church. With much difficulty the al- tercation was arrested, but the papers of the Bureaus were found in the most confused state. After using our most powerful magnifying glas- ses, and two of our compositors on unintelligible copy, we are able to present what seems to be a correct statement of the potency of the two Bu- reaus in the late election. While the fruits may be regarded as insufficient for the outlay, it must be considered that probably the managers were as much to blame as the Bureaus. The follow- ing is the account as made up of

THE VOTERS' COMMISSARY BUREAU.

The Bureau Dr.	
To 16 bbls. Superfine Flour	$176 00
" 5 Sheep, with the wool	40 00
" 10 cords of wood	49 00
" 47 gall's whisky	109 40
" 13 bush. corn meal	13 00
" 240 lbs. bacon, old	5 40
" 240 qts. chestnuts	4 80
" 547 lbs. sugar	5 40
" One wood-horse	75
" Three wood-saws	6 00
" 300 yds. assorted calico	75 00
" Assorted baby-clothes	64 00
" 16 gals. home-made rum	40 00
" Children's toys, assorted	39 00
" Candies for children of voters	27 00
" Sundries	194 00
Total	$838 55
The Bureau, Cr.	
By two votes @ $419,271	$838 55

It is proper to say in justification of the officers of this Bureau that they promised more than double what they paid out, and that they *expected* a much larger vote for their ticket as the result of their labors. Why the people did not vote as they promised amidst the profusion of country produce, the officers are unable to explain. They

HON. EDWARD M'PHERSON, CLERK OF CONGRESS.

Hon. Edward M'Pherson was born in Gettys- burg, Pa., on the 31st of July, 1830, and is there. In 1862 he ... (from) Congress, and was el-

two days before the election, defeated him, and Gen. A. H. Coffroth was chosen.

COMMANDER MYERS' T

UNION HEAD
Chambersburg, Oct. 11
To F. M. Kimmell, Commanding Dem Forces:

SIR—Your note of this evening ask on which I will accept the surrender Insurgent Forces under your comman In reply I would say, that peace be there are but a few conditions I must i
1. That the men surrendered shall i assailing the loyal cause, either in pea
2. That they shall forever be disque negro riots, and for becoming or aiding
3. That they shall henceforth make on all subjects they may discuss.
4. That they shall not abed innocen butcher shops before elections.
5. That they shall abolish the Vote reau, and cease bartering rations for v
6. That they shall cease selling A. market for votes, and especially shal to seventeen men, and then give it to
7. That they shall cease ever apple ing, encouraging, and abetting treason
8. That they shall punish traitors ces than putting them into the Senate
9. That they shall not derange t changing greenbacks for wood, cord s Upon the acceptance of the forego will be paroled, and the officers will retain side-arms and baggage as follo
One nigger on the brain.
One nigger in each wood-pile.
One nigger bureau.
One nigger forbidden to marry the
One nigger female forbidden to ma
One nigger of the mixed persuasio
One nigger—tis's born.
All nigger cards, hand-bills, place
It is to be understood, however, th are solely for private use, and they s into the face of the public to the dis, and decent citizen, as heretofore.
Hoping that the terms proposed be that this fearful and godless effus

This edition of the *Old Flag* is dated Wednesday, October 17, 1866, and was published in Chambersburg by A. K. McClure, a state politician and journalist, and H. S. Stoner, Esq., a local businessman. Newspapers of this era had a definite political affiliation. McClure and Stoner also published the *Franklin Repository*, which was pro-Republican and pro-Lincoln, prior to Abraham Lincoln's assassination. The other prominent newspaper of the day was the *Valley Spirit*, which took a pro-Democratic position and an anti-Lincoln stance.

FRANKLIN COUNTY
CENTENNIAL CELEBRATION!

The Following order of Formation
WILL BE OBSERVED FOR THE

Trades Display, Tuesday, Sept. 9.

AT CHAMBERSBURG, PA.

1. ANTRIM.	7. LETTERKENNY.	13. WARREN.
2. LURGAN.	8. WASHINGTON.	14. ST. THOMAS.
3. PETERS.	9. MONTGOMERY.	15. QUINCY.
4. GUILFORD.	10. SOUTHAMPTON.	16. CHAMBERSB'G.
5. HAMILTON.	11. GREENE.	
6. FANNETT.	12. METAL.	

Antrim Township
will form on Greencastle road, right at Garfield Street, facing North.

Lurgan Township
will form on Garfield and Second Streets, right at Main Street, facing West.

Peters Township
will form on Second and Catharine Streets, right at Boyer Street, facing South.

Guilford Township.
Fayetteville District, on Second Street, right at Catharine.
New Franklin District will form on Second Street, right at Garfield, facing North. Fall in rear of Fayetteville District at corner of Second and Garfield.
Marion District, form on Greencastle road, in rear of Antrim delegation. After Antrim moves off, march to corner of Garfield and Main, wait until Fayetteville and New Franklin pass by, then fall in the rear of these delegations.

Hamilton Township
will form on Catharine and Water Streets, right at Main facing East.

Fannett Township
will form on Second and Washington Streets, right at United Brethren Church, facing South. Follow Fayettville delegation of Guilford Township to Second and Garfield, then to Garfield and Main Streets, halting at each of these corners to allow New Franklin and Marion Districts to fall in the rear of Fayetteville. Then proceed to Corner of Catharine and Main and fall in the rear of Hamilton.

Letterkenny Township
will form on Second and Queen Streets, right at Washington, facing South.

This is a program from the Franklin County centennial parade of trade displays, depicting the history of the county, on Tuesday, September 9, 1884, in Chambersburg. The procession began at 10:40 a.m. and was over four miles long.

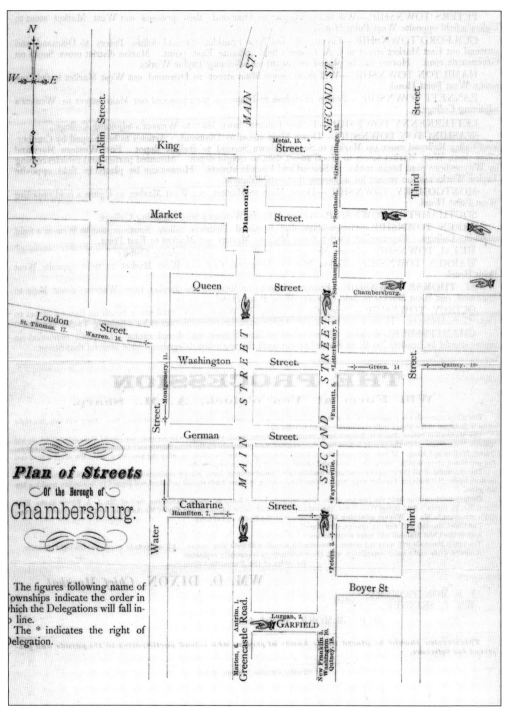

N

W→ ←E

S

Franklin Street.

MAIN ST.

SECOND ST.

Street.

King Street.
Metal. 15. *Greenvillage. 13.

*Scotland.

Third

Market Street.

Diamond.

*Southampton. 12.

Queen Street.
Chambersburg.

Loudon Street.
St. Thomas. 17. Warren. 16.

S T R E E T .

S E C O N D S T R E E T .

*Letterkenny. 9.

Washington Street.
*Montgomery. 11. *Funnett, 8. Green. 14 Quincy. 18

M A I N

German Street.
*Fayetteville. 4.

Plan of Streets
Of the Borough of
Chambersburg.

Catharine Street.
Hamilton. 7.
*Peters. 3.

Water

Third

Boyer St

The figures following name of townships indicate the order in which the Delegations will fall in-to line.
The * indicates the right of Delegation.

Marion, 6.
Antrim, 1.
Greencastle Road.

Lurgan, 2.
GARFIELD

New Franklin 5.
Washington 10.
Quincy. 18.

This map of the Franklin County centennial shows the parade route of the trade displays. The incredible celebration of Franklin County's centennial actually began on Monday, September 8, 1884, with a huge parade that consisted of the Grand Army of the Republic, bands, drum corps, secret societies, and fire companies.

Washington Township

will form on Waynesboro road. After New Franklin delegation falls in line, march to Second and Garfield Streets, halt until Fannett and Letterkenny pass by, then fall in,

Montgomery Township

will form on Water Street, right at German facing South. Follow Hamilton up Catharine to Main. Halt at corner of Main and Catharine, and fall in rear of Washington.

Southampton Township

will form on Second and Market Streets, right at Queen, facing South. Follow Letterkenny to Second and Garfield. Halt until Washington gets into line, then proceed to Main and Catharine Streets, and fall in rear of Montgomery.

Green Township

will form on East Washington Street, right at Second, facing West. If necessary, Scotland and Greenvillage districts can form on Second Street, right at Market. After Southampton clears Market Street, follow them to Washington Street to join Fayetteville delegation.

Metal Township

will form on King Street, right at Second, facing East. If Second Street is not occupied by Greenvillage and Scotland close up the gap in rear of Southampton to Washington Street, then fall in rear of Green.

Warren Township

will form on Water and Loudon Streets, right at Washington, facing South. Follow Montgomery to Main and Catharine. Halt until Metal Township passes, then fall in the rear.

St. Thomas Township

will form on Loudon Street, rear of Warren Township. In case there should be no delegation from Warren close up on Montgomery, on Water street, follow them to Main and Catharine and halt until Metal delegation passes, then fall in their rear.

Quincy Township

will form on East Washington Street, in rear of Fayetteville delegation of Green township. Follow them to corner of Second and Washington. Halt until Metal passes that point then proceed to corner of Main and Catharine. Halt until St. Thomas gets into line. Quincy delegation coming by Waynesboro road will halt at Second and Garfield Streets and fall in the rear of other delegation.

Chambersburg

will form on East Queen Street, right at Second facing West. After Metal township clears Queen Street, fall in their rear, move to Washington and halt until Quincy township clears Washington Street, follow them to Second and Garfield, and halt until balance of Quincy township, coming by Waynesboro road, get in line, then fall in their rear. In case the Quincy delegation should all come by Waynesboro road, follow Metal to Second and Garfield, and halt until Quincy gets into line.

ROUTE OF PROCESSION:

Down Main to Market, Market to Federal, Federal to King, King to Main, Main to Market, Market to Queen, Queen to Second, Second to Garfield, Garfield to Main and dismiss.

In order to prevent confusion Marshals will dispose of their delegations as follows:

ANTRIM TOWNSHIP.—Will move South on Main Street until Western Maryland Railroad is cleared. Horses can be left on the East side of the road or on the vacant lot at Taylor Works, entrance from Lincoln street.

LURGAN TOWNSHIP.—Will turn to right move down Main street to Weaver's field adjoining Wilson College.

This portion of the program shows where and how the townships were to form. The municipalities told the Franklin County story with floats about history and industry, marching bands, and Conestoga wagons. Over 4,000 people marched in the procession.

PETERS TOWNSHIP.—Will follow Lurgan to Diamond, then proceed out West Market steet to Uglow's field opposite West Point Hotel.

GUILFORD TOWNSHIP.—Fayetteville and New Franklin districts follow Peters to Diamond, and proceed out East Market street to J. A. Eyster's field opposite East point. Marion district move South on Greencastle road. Horses can be placed on vacant lot adjoining Taylor Works.

HAMILTON TOWNSHIP.—Will move down Main street to Diamond, out West Market to field opposite West Point Hotel.

FANNETT TOWNSHIP.—Follow Hamilton to Diamond, then proceed out Main street to Weaver's adjoining College.

LETTERKENNY TOWNSHIP.—Follow Fannett down Main to Weaver's adjoining College.

WASHINGTON TOWNSHIP.—Down Main street to Diamond. Articles to be shipped by Cumberland Valley Railroad move up Market to Second, down Second to freight depot. For Western Maryland move down West Market street to Hood street then to freight depot. Mounted parties and vehicles coming by Waynesboro road break ranks at Second and Lincoln streets. Horses can be placed in field opposite Taylor Works and on vacant lot adjoining that establishment.

MONTGOMERY TOWNSHIP.—Down Main to Market, out West Market to Uglow's field opposite West Point Hotel.

SOUTHAMPTON TOWNSHIP.—Down Main to Weaver's field adjoining College.

GREEN TOWNSHIP.—Greenvillage and Scotland Districts follow Southampton to Weaver's field adjoining College. Fayetteville district down Main to Market out Market to East Point.

METAL TOWNSHIP.—Down Main street to Weaver's field adjoining College.

WARREN TOWNSHIP.—Follow Metal to Diamond, then out West Market to field opposite West Point Hotel.

ST. THOMAS TOWNSHIP.—Follow Warren (or Metal if no display from Warren) down Main to Diamond, out West Market to field opposite West Point Hotel.

QUINCY TOWNSHIP.—Delegations coming by Waynesboro road move South on Second Street to clear Garfield Street. Horses can be placed in field opposite to or on vacant lot adjoining Taylor Works.

CHAMBERSBURG division will move on to Main Street, and break ranks. To avoid confusion no teams should be headed North on Second Street until the township delegations have cleared that Street.

THE PROCESSION
Will Form at Ten o'clock, A. M., Sharp.

Township Marshals are requested to have their delegations in line, ready to move at that hour without fail. They will halt the right of their divisions at the places indicated until ordered to close up.

The Marshals of Peters, Fannett, Letterkenny, Southampton and Metal Townships will see that the rear of their delegations do not obstruct Main Street while the parade is forming. If necessary mass your men on the cross Streets viz: Catharine, German, Washington, Queen, Market and King. If from any cause there should be a break in the line likely to delay the procession, have the street cleared and the gap closed up promptly. *Keep your ranks well closed up during the entire parade.*

The managers of all the turnpike companies leading into Chambersburg have kindly consented to pass free of toll all organized processions under Marshals on Tuesday Sept 9th. Delegations coming by these roads should be halted and formed in line before reaching the toll gates.

Township delegations have the free use of the Cumberland Valley Railroad Stock Yards, the field of Mr. J. A. Eyster at the East Point, Mr. B. Uglow's field at the West Point; the field opposite and the lot adjoining the Taylor Works at the South end of town and two fields belonging to Mr. A. Weaver adjoining Wilson College at the North end of town.

The Chief Marshal will wear an orange colored sash.

Aids to the Chief Marshal will wear white sashes.

Township Marshals will wear red sashes. Assistant Marshals will wear blue sashes. All sashes to be worn over the right shoulder.

A careful study and a strict compliance with these instructions is earnestly requested.

By order of the Executive Committee.

WM. D. DIXON, *Chief Marshal.*

P. B. MONTGOMERY, } *Aids.*
WM. P. SKINNER, }

B. F. GILMORE, *Special Aid.*

This circular should be placed in the hands of persons who intend participating in the parade and preserved for reference.

"Public Opinion," Steam Print.

The final page of the program tells how the various township delegations would be dismissed. From midnight to 1:00 a.m., Franklin County welcomed its 100-year anniversary with the pealing of church and fire bells and mill whistles blowing nonstop for one hour. The day culminated with a fireworks celebration. Attendance of the two-day event was more than 20,000 people each day.

24

This is an 1884 photograph taken by the well-known photographer H. Frank Beidel during the Franklin County centennial celebration. This view looks northwest into the diamond. The banner in the foreground says "bowling alley."

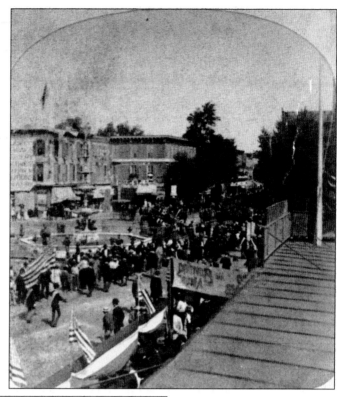

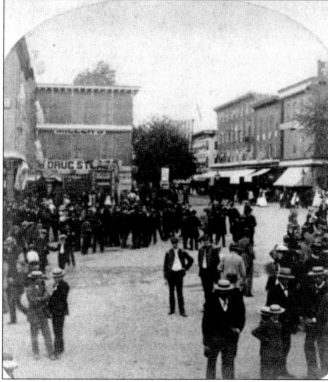

This photograph, taken from the front of Central Presbyterian Church, shows another view of the county's centennial celebration of 1884. It shows North Main Street as people are gathering for the festivities.

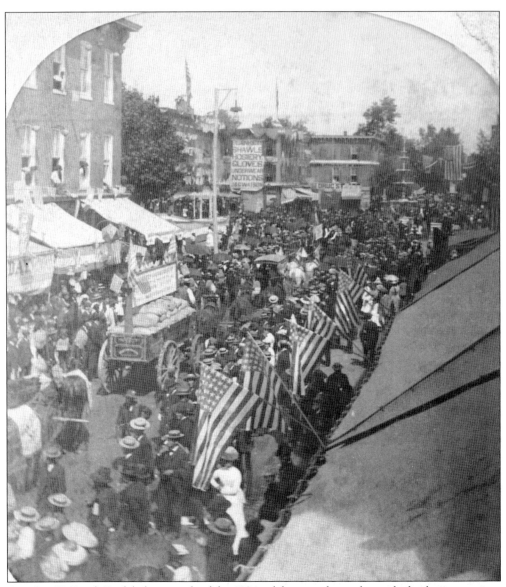

Another H. Frank Beidel photograph of the 1884 celebration shows the trade display procession. The Quincy Township procession included a wagon with a fully operating forge and charcoal pit. The Chambersburg procession included more than 200 employees of the Cumberland Valley Railroad.

This 1884 centennial photograph shows the wagon selling ice-cold lemonade. Reports of the day describe it as very sunny and very hot.

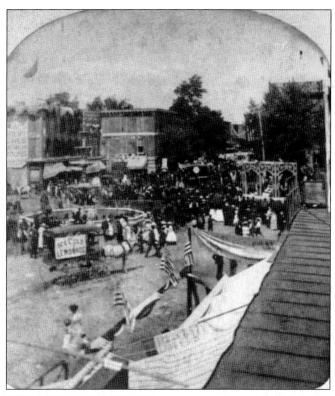

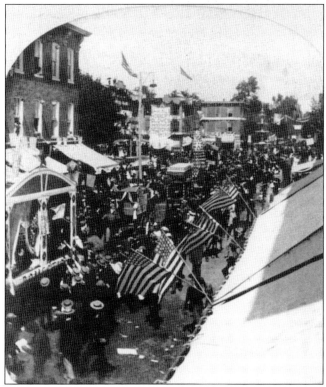

This final photograph of the centennial of 1884 shows the trade display winding toward the square, flags waving in the breeze. A series of speakers, including James Chambers, addressed the crowd after the trade display procession.

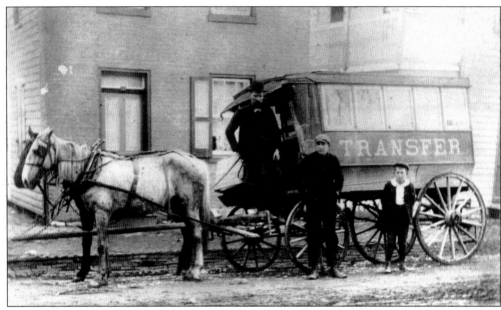

Shown in this photograph is the Chambersburg taxi. This 1885 scene is on North Second Street. The taxi transported passengers from the Cumberland Valley Railroad station to their destinations within Chambersburg.

Preamble and Resolutions

ADOPTED AT A MEETING OF

Town Council of the Borough of Chambersburg, Penna.,

HELD JANUARY 5, 1891.

WHEREAS, The question of Electric Lighting having been referred to a committee who after some investigation find that it is evident from information obtained from corporate authorities of a number of Boroughs and from our own experience since the construction of an electric light plant by the Borough for street lighting, that the streets are better lighted and at a lower rate than could be done by a private company and has proven to be a very desirable investment ; and

WHEREAS, That if the power to do commercial lighting was extended to the corporate authorities of Boroughs owning electric light plants, the operating of the two systems together would not only lessen the cost of street lighting but would enable the corporate authorities of Boroughs to furnish its inhabitants with commercial lights at lower rates than that asked by private companies and in this manner both the taxpayer and consumer would be directly benfitted ; and

WHEREAS, There will be introduced at the next session of our State Legislature a bill granting to the corporate authorities of such Boroughs as may desire to do so the authority to furnish commercial lights to the citizens of such municipalities ; and

WHEREAS, The intention of the bill is for the best interest of the taxpayer as well as consumer, and at the same time to protect capital already invested ; it should appeal to popular favor, inasmuch as legislation of this nature has already been conceded to cities of 1st, 2d and 3d classes and we see no just reason why the same power should not be granted to Boroughs by the passage of this bill ; therefore be it

Resolved, By the Burgess and Town Council of the Borough of Chambersburg, Pa., that our State Senator and members of the House of Representatives be earnestly requested to give this bill careful thought and support and endeavor by all honorable means to secure the passage of the bill at an early date.

Resolved, That the municipal authorities of all Boroughs of the Commonwealth be requested to take such action as they deem most wise to secure the favor and interest of the members of the Legislature from their district and in this manner aid in the passage of this bill.

Resolved, That the clerk be instructed to have the necessary number of copies of this preamble and resolution and bill printed and forward copies to the Burgess and Town Councils of each Borough within the Commonwealth and

This is the preamble and resolution that was adopted by the borough of Chambersburg's town council on January 5, 1891, in support of extending commercial lighting capability to the corporate authorities of boroughs that owned electric plants. This preamble refers to Chambersburg's production of electricity for streetlights in 1889. This document set the stage for the borough to begin producing and selling electricity to borough residents in 1893.

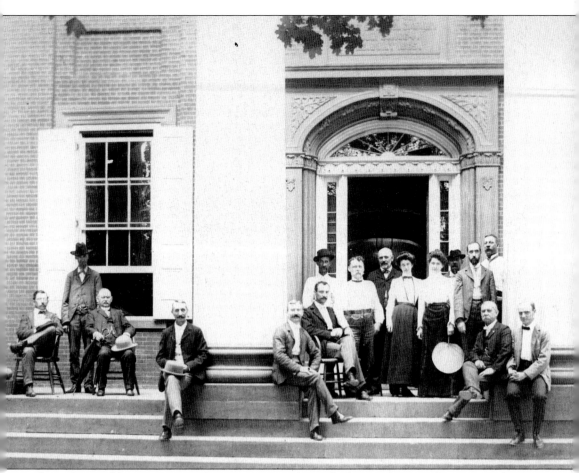

This is the Franklin County courthouse on a warm day in the late 1890s. Note the open windows and fan. The three gentlemen on the left are the Franklin County commissioners, and to the right are other employees of the county.

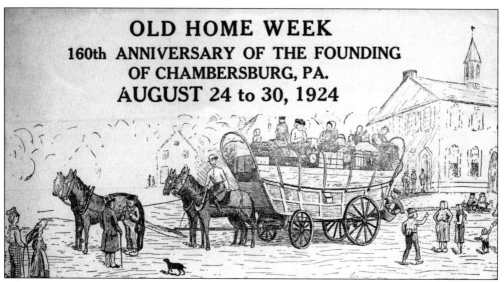

This is a rare advertising envelope from the Chambersburg Old Home Week, celebrating the 160th anniversary of the founding of Chambersburg. The etching shows a likeness of the first Franklin County courthouse and a Conestoga wagon carrying passengers and freight.

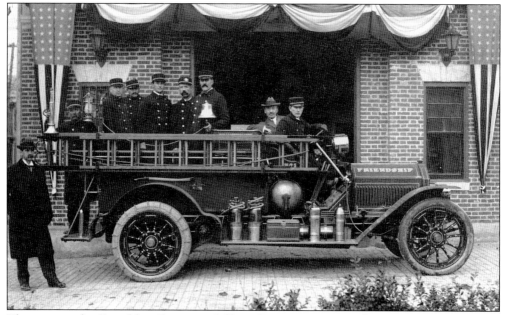

This view is the Friendship Engine and Hose Company No. 1 with its new 1911 American LaFrance chemical engine at the fire station located at the east point in Chambersburg. The company was organized in 1780. Today the building houses Sollenberger's Messenger Service.

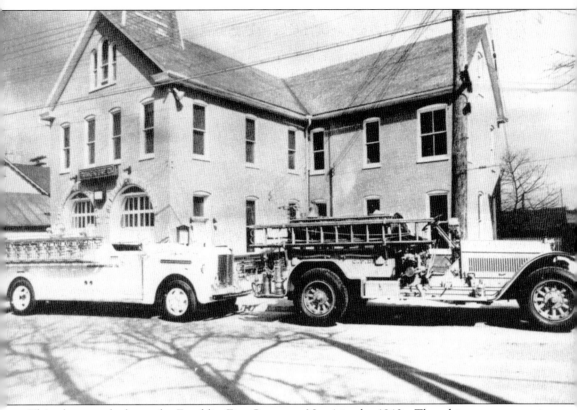

This photograph shows the Franklin Fire Company No. 4 in the 1940s. The white apparatus to the left is a 1941 Pirsch that was used in the community and the borough of Chambersburg. The apparatus to the right is a 1925 American LaFrance rotary pumper, which is owned by the Franklin Fire Company and displayed at its station at the corner of King and Franklin Streets in Chambersburg.

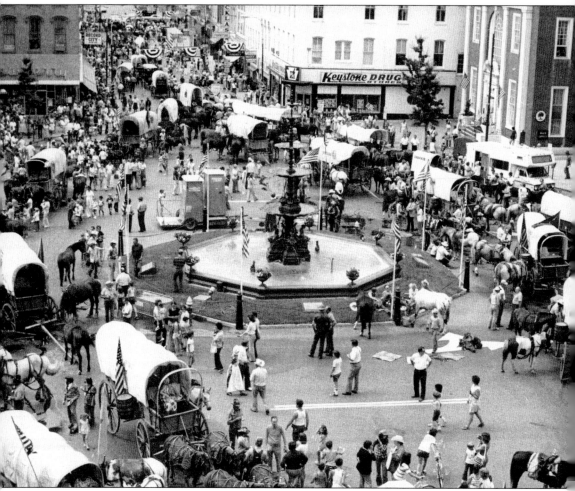

This 1976 photograph depicts the American Bicentennial Conestoga Wagon Train passing through the square of Chambersburg.

Three

IN AND AROUND
GREENCASTLE

The area of Greencastle was established by Scotch-Irish settlers on land that Native Americans used as a resting place when hunting buffalo. About 1750, Samuel Smith secured the land that would be Greencastle from the Penn family. Ultimately this land was sold to William Allison and passed to his son John Allison, who served as a colonel in the Revolutionary War. The younger Allison laid out the borough of Greencastle in 1782 and distributed it by a lottery. The plat of land was divided into 246 equal parcels, each parcel was numbered, and 246 tickets were sold for $8 a piece. Every participant was guaranteed a parcel with the chance of receiving a premium, more valuable tract.

Greencastle had fertile limestone soil and good access to water. Agriculture was the main industry. A few grain and lumber milling operations located along the Conococheague Creek in the early days of the settlement. Construction of the Waynesboro, Greencastle and Mercersburg Turnpike—part of a larger road system that connected Pittsburgh to Baltimore—took place in 1840. New businesses and shops sprang up in Greencastle and attracted new residents and workers. In 1859, another turnpike road was constructed to Williamsport, Maryland, a towpath town along the Chesapeake and Ohio Canal, and spurred further growth in the Greencastle area.

Home and building trades expanded. An 1870 census of manufacturing in the borough of Greencastle shows J. B. Cromwell and Company as the largest area employer with 14 employed to produce agricultural implements; 10 to produce sashes, blinds, and doors; and 6 in the foundry and machine shop. Total wages for all three divisions were $15,700. The next largest employer in Greencastle was Hoover and Johnson with eight employees. The company produced carriages, buggies, and wagons and contributed $2,300 in wages to the local economy.

The second wave of the Industrial Revolution was beginning in Greencastle. The industrial processes, transportation systems, and communication modes pioneered in the early part of the 1800s were being implemented on a larger scale. The Liberty Bell was coming to town, businesses were using typewriters, and the first automobile was sharing the road with horses and carriages.

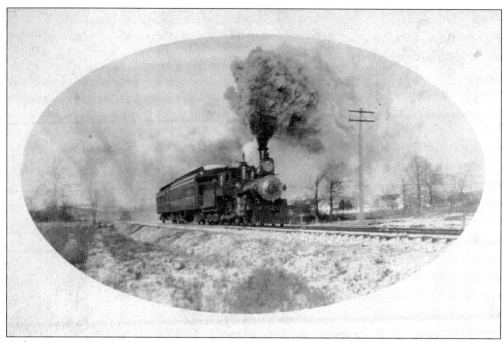

A fast-moving Cumberland Valley Railroad passenger train is nearing the Marion station in 1904. Marion was first called Independence, but when a post office was established, the name was changed to Marion in honor of the Revolutionary War general Francis Marion.

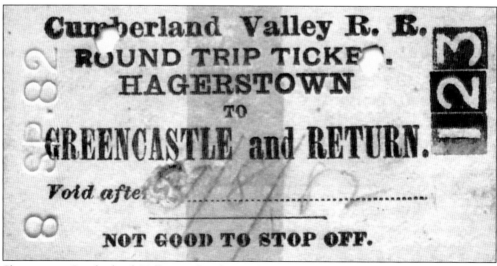

Shown is a Cumberland Valley Railroad round-trip ticket from Hagerstown, Maryland, to Greencastle, dated September 8, 1882.

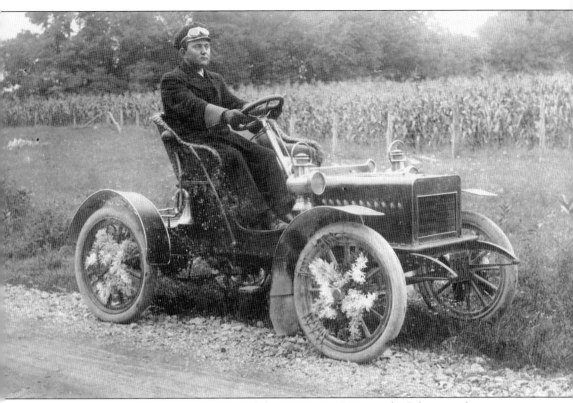

This 1905 Oldsmobile was the first automobile to come to Greencastle. It has a six-horsepower, one-cylinder engine that could take nearly all hills in low gear. Occasionally the driver, C. E. Omwake (shown in his driving attire), would have to get out and push.

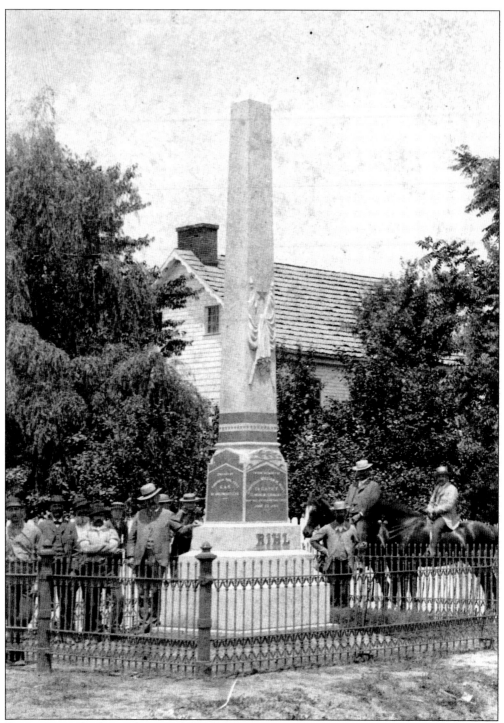

An exceptional cabinet photograph by Rogers and Haffner shows the newly erected monument to the memory of Cpl. William H. Rihl, who was the first Union soldier killed in action on Union soil, on June 22, 1863. The monument was placed at his grave in 1887 and still stands near Greencastle on Fleming Farm along Route 11.

An advertisement of the early 1900s shows several businesses in Greencastle. The advertisement publicizes trolley access.

Hotel McLaughlin

GREENCASTLE, PA.

ROOMS WITH OR WITHOUT BATH
ALL TROLLEY CARS STOP AT THE DOOR

ELMER GONSO	MARY BARNHART
All Kinds of	**MILLINER**
HORSE GOODS	
GREENCASTLE, PA.	GREENCASTLE, PA.

U. B. BARNHART

Dealer in Dry Goods, Notions, Linoleums,

Boots, Shoes, Etc.

GREENCASTLE, -- -- PENNSYLVANIA

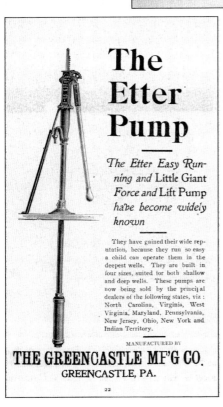

The Etter Pump

The Etter Easy Running and Little Giant *Force and* Lift Pump *have become widely known*

They have gained their wide reputation, because they run so easy a child can operate them in the deepest wells. They are built in four sizes, suited for both shallow and deep wells. These pumps are now being sold by the principal dealers of the following states, viz : North Carolina, Virginia, West Virginia, Maryland, Pennsylvania, New Jersey, Ohio, New York and Indian Territory.

MANUFACTURED BY

THE GREENCASTLE MF'G CO.
GREENCASTLE, PA.

22

An advertisement of the Greencastle Manufacturing Company shows the Etter Pump, a lift pump. A lift pump creates a vacuum and raises the level of water.

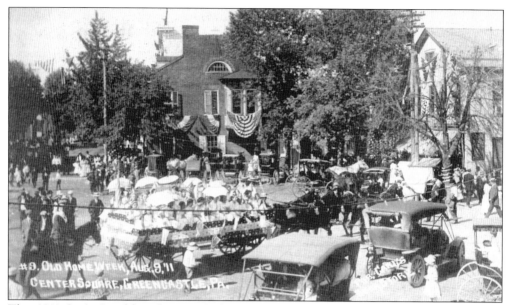

This 1911 C. A. Laughlin photograph shows an old home week parade passing through the center square of Greencastle. Old home week of Greencastle is a triennial celebration that began in 1902. The photograph was published by Carl's in Greencastle.

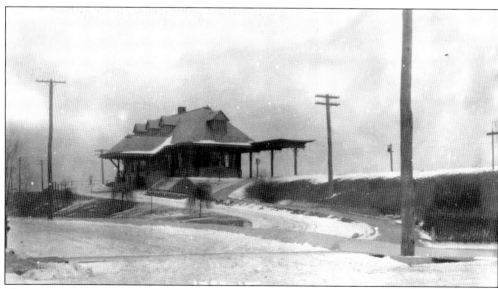

The snow surrounds the Cumberland Valley Railroad passenger station at the high line in Greencastle in this January 27, 1915, photograph. The rail station remains today.

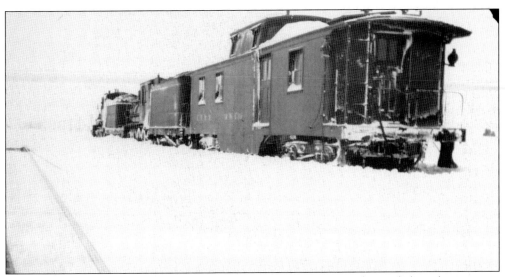

Snow came to the Cumberland Valley Railroad station in Marion and stranded two locomotives and a maintenance right-of-way car, as seen in this January 29, 1918, photograph. The locomotives and cars were heading to Greencastle.

This sick pay benefit slip was issued by the secretary of the Cumberland Valley Railroad Relief Association so that a sick employee would receive compensation although he was not able to work. The slip is dated April 23, 1917.

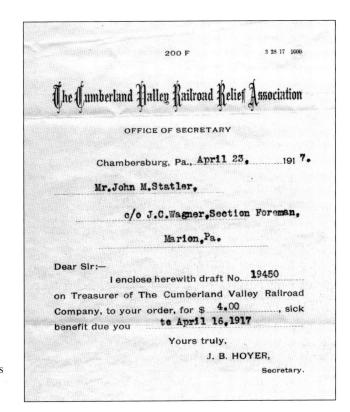

200 F 3 28 17 1000

The Cumberland Valley Railroad Relief Association

OFFICE OF SECRETARY

Chambersburg, Pa., April 23, 191 7.

Mr. John M. Statler,

c/o J.C. Wagner, Section Foreman,

Marion, Pa.

Dear Sir:—

I enclose herewith draft No. 19450

on Treasurer of The Cumberland Valley Railroad

Company, to your order, for $ 4.00 , sick

benefit due you to April 16, 1917

Yours truly,

J. B. HOYER,

Secretary.

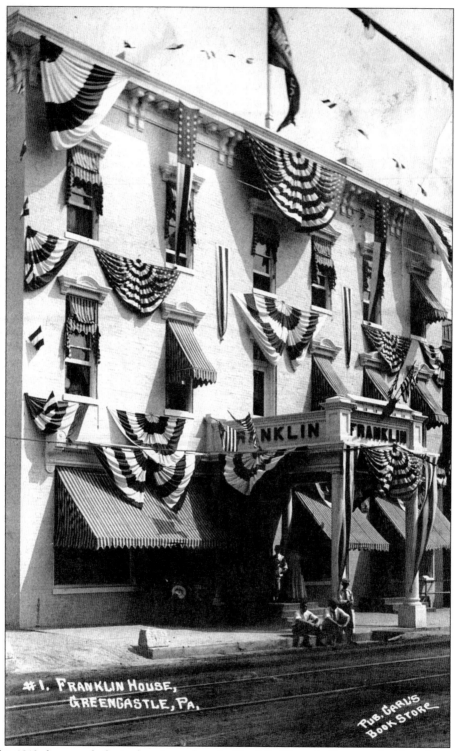

In this 1912 photograph, festive buntings adorn the Franklin House in Greencastle. Note the trolley tracks of the Chambersburg, Greencastle and Waynesboro Street Railway in the foreground.

40

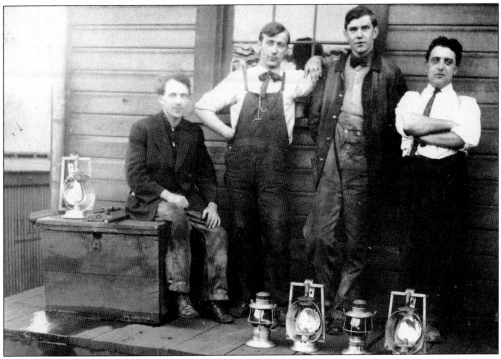

These employees of the Cumberland Valley Railroad, posing in front of the station in Williamson that is located next to Sniders Elevator, are ready for service in this 1912 photograph. Note the variety of railroad lanterns.

The average farmer eats Baltimore canned foods and wears Baltimore made clothing. He gets up at the alarm of a Connecticut clock and washes his face with Buffalo soap in a Pennsylvania wash pan.

Then he sits down to a Grand Rapids table and eats Indian hominy fried in St. Joseph's lard on a St. Louis stove.

Then he puts a Baltimore bridle on a Tennessee mule and plows a farm covered by an Ohio mortgage.

When bed time comes he reads a Bible written in Chicago, and says a prayer printed in Jerusalem. Then he crawls under a pair of bed blankets made in New Jersey, and is guarded by a dog—the only home-raised product he has on his farm.

It is different with the farmer who buys his goods from our store, he gets everything he wants but the dog.

SWARTZ BROS.

Swartz Brothers in Marion used this as wrapping paper in the early 1900s. It is certainly a "buy local" message.

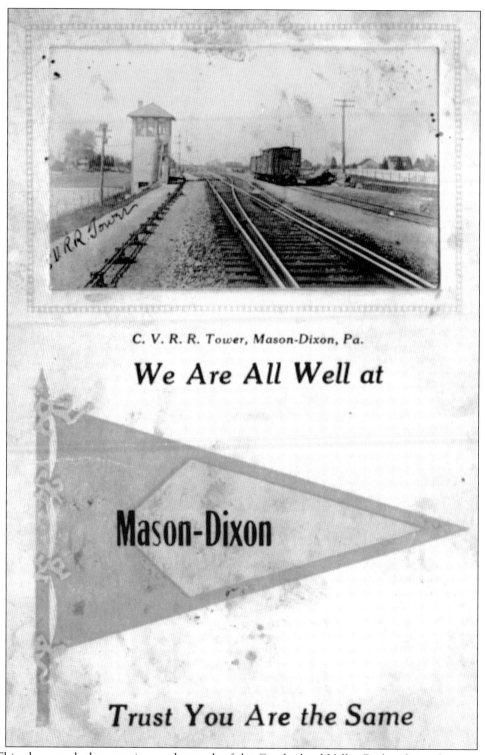

C. V. R. R. Tower, Mason-Dixon, Pa.

We Are All Well at

Mason-Dixon

Trust You Are the Same

This photograph shows a view to the south of the Cumberland Valley Railroad signal tower at Mason-Dixon, Pennsylvania, in the early 1900s.

A letter, written by J. H. Ledy of Marion on July 30, 1900, requests a quote of merchandise from Smith Manufacturing of Waynesboro.

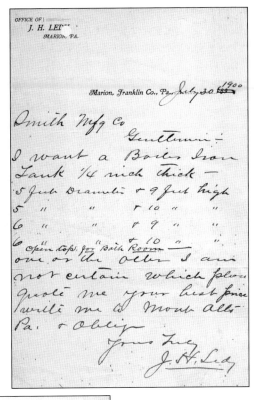

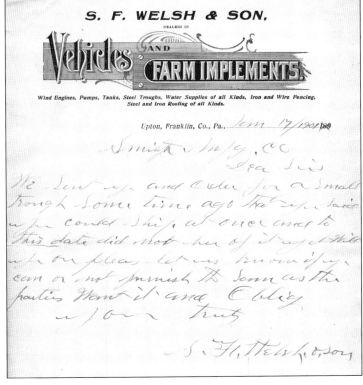

This 1901 letter to Smith Manufacturing from S. F. Welsh and Son of Upton inquires about a trough that was ordered. S. F. Welsh and Sons supplied farm implements to Franklin County residents in the Upton area. Upton was originally laid out by George Cook in 1840.

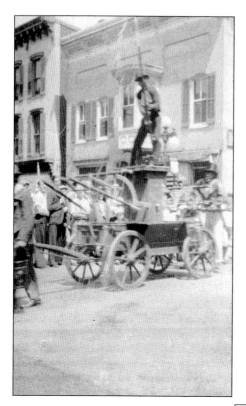

In the early 1900s, a capable fireman of the Rescue Hose Company demonstrates the 1741 hand pumper in a firemen's parade in Chambersburg. The Rescue Hose Company still owns the hand pumper.

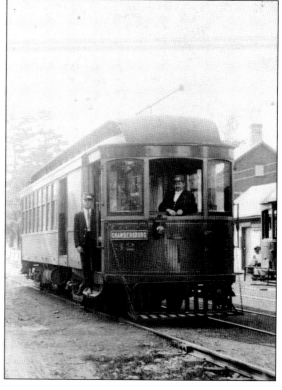

A Chambersburg, Greencastle and Waynesboro trolley car enters Shady Grove on its way to Greencastle in the early 1900s. In the right background is the front of a Hagerstown and Frederick trolley car at the Shady Grove Union Station.

H. B. HESS.
KAUFFMAN,
FRANKLIN COUNTY, PA.

Kauffman, Pa. Jan 26 1906

Dear sir. According to promise
I will give an account of my
trip to Marion Bridge they seem
to want electric lights and the
town is talking of putting in
a plant for it self some time but
do not seem to be ready to do it yet
for a while prof Wine said it will
require about 175 lights so you
have an idea of the size of an engine
I think they want all the small
lights I think that is what you
call incadescent lights.
I also talked to my brother the other
day and he seems to think he will
not buy an engine this winter
any more

how are you getting along with
your stock company business if I
have a guarantee that the thing will
pay I will take ten or twelve shares
and if you should want to have
a director up this way may be
could act for you but do not want
to force my self in.
Hoping to hear from you soon
I am very truly yours
H B Hess

An unusual communication from H. B. Hess in Kauffman to a gentleman in Marion discusses establishing an electric plant and placing electric lights in Marion. The letter, dated January 26, 1906, mentions that electrifying Marion would take about 175 lights.

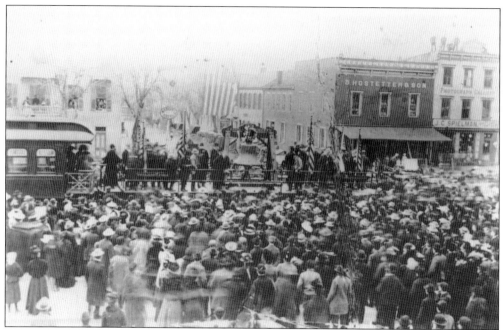

On January 6, 1902, the Liberty Bell passed through Franklin County on its way to the Charleston Exposition. Although it was a cold day, a large crowd turned out in Greencastle, and some took to the rooftops for a better view.

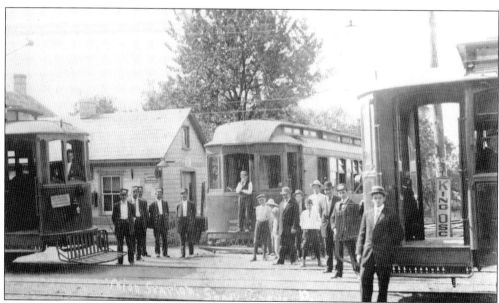

This is the union station, the junction of the Greencastle and Waynesboro trolley lines and the Hagerstown line, at Shady Grove in the early 1900s. Two Chambersburg, Greencastle and Waynesboro trolley cars face each other. Between these two trolley cars is a Hagerstown and Frederick streetcar.

Four

AROUND WAYNESBORO

John Wallace Sr. warranted the two parcels that would be Waynesboro from the Penn family in 1749 and 1751. The parcels totaled 633 acres. The early settlement was called Mount Vernon and later became known as Wallacetown. After the elder Wallace's death, the land passed through the Wallace family to John Wallace Jr., the town's founder. Wallace Jr. apportioned 90 plots in the town and named the town Waynesburg. Local tradition says that Wallace Jr. named the town after Gen. Anthony Wayne, whom he served under in the Revolutionary War and who once commented on the countryside "as a lovely place to build up a town." Because Pennsylvania had more than one Waynesburg, the town's name changed to Waynesboro in 1831 when post office regulations required that no locations within the state share a name.

Manufacturing took a stronghold in Waynesboro. Waynesboro had good access to waterpower and was located on the turnpike from Baltimore to Pittsburgh. Access to the Cumberland Valley Railroad and the Western Maryland Railroad also aided the development of manufacturing. In 1870, the Geiser Manufacturing Company, manufacturers of threshing and harvesting machines, employed 88 people and paid yearly wages of $34,575. The Frick and Bownman Company manufactured steam engines and operated a foundry, employed 35, and paid $15,000 in wages annually.

In the same year, the nearby Mont Alto Iron Company employed 340 people in its iron-manufacturing business and paid $168,000 in annual wages. At its peak, the iron company employed 500—both men and women. Production in 1870 was about 15 tons of pig iron, which is the raw iron that comes when melting iron ore, coke, and limestone in a blast furnace. In 1880, the furnace was enlarged and the capacity of raw iron production increased to 35 tons per day. In the 19th century, Pennsylvania led the nation in iron production and produced twice as much as the second-ranked state, New York.

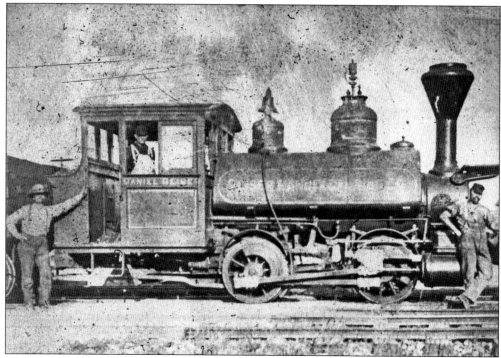

This rare late-1800s photograph shows the locomotive *Daniel Geiser* of the Geiser Manufacturing Company in Waynesboro. In 1881, Geiser invented the first "peerless" steam engine, which it used in the production of its farm equipment.

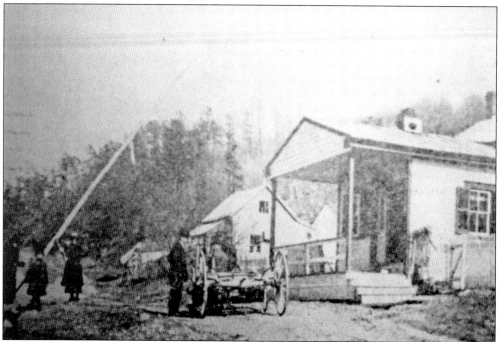

This is a shot of the tollgate at Rouzerville in the late 1800s. Rouzerville was first laid out in 1868.

The Mount Pleasant Fire Company No. 8 from Harrisburg made an annual excursion to Mont Alto Park. This program is from the August 14, 1877, excursion. Mont Alto Park was opened by the Mont Alto Iron Works in 1875 to provide recreation to its employees. The park offered a carousel, swimming, hiking, and picnicking in a beautiful setting. With access by rail, the park was a popular place. It remains today and is the oldest state park in Pennsylvania.

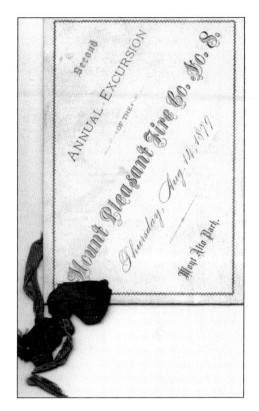

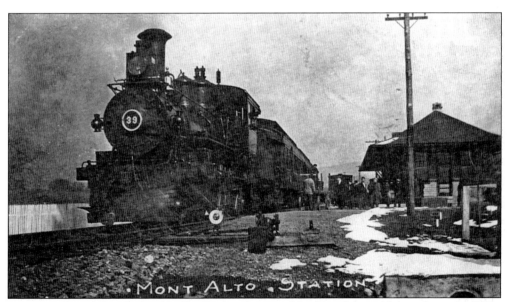

Passengers board Cumberland Valley Railroad engine No. 39 at Mont Alto in the early 1900s. Mont Alto was originally named Funkstown after the first settler to the area, John Funk, built a home in 1817 along the east bank of the West Branch of Little Antietam Creek.

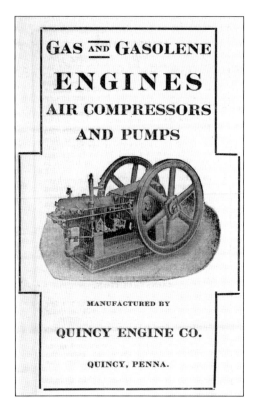

The cover of a 1907 advertisement booklet promotes Quincy Engine Company, an early producer of gasoline engines. Quincy Engine Company also produced alcohol engines, air compressors, and pump jacks.

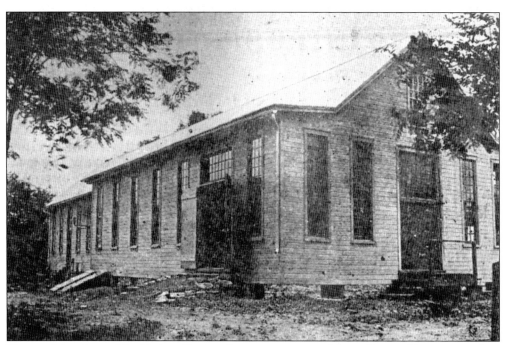

The machine shop of the Quincy Engine Company is pictured here. Quincy Engine owned its own iron ore mine and foundry.

Another advertisement for the Quincy Engine Company, from around 1907, tells the business product line.

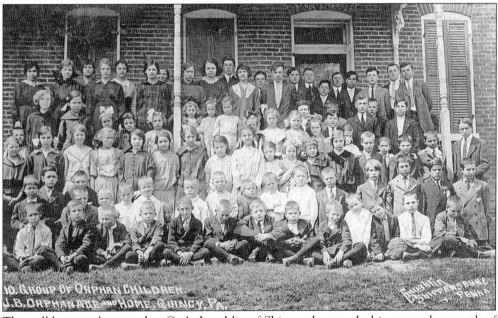

The well-known photographer C. A. Laughlin of Shippensburg took this group photograph of the children at the Quincy Orphanage and Home in the early 1900s. Harvey and Henrietta Kitzmiller gave 163 acres for the orphanage in 1902, and it opened and began caring for children in 1903.

Whereas Charles Hoch late of Quincy Township, County of Franklin, and State of Pennsylvania, by his last Will and Testament, dated the 21st October A.D 1863, duly proven, bequeathed to the Seventh Day Baptist Monastical Society at Snow Hill, a legacy of One thousand dollars, now know all men by these presents, that we Saml Snowberger, George Specht, Henry Bauman John Burger, and Henry Ritter, trustees of the above named legatee, do acknowledge to have this day had and received, of and from Wm Fleagle, Executor of the last will and Testament, of the aforesaid Charles Hoch Decd, the just and full sum of, one thousand dollars (the U.S. legacy tax, and collateral tax, having first been deducted therefrom) in full of said legacy, and we do by these presents, for ourselves our Successors in office, our heirs Executors and administrators remise release quit claim, and forever discharge, the said Wm Fleagle Executor as aforesaid, his heirs Executors and administrators, of and from said legacy, and of and from all claims and demands, for or on account of Same witness our hands and seals this

Witness Sixth day of April A.D 1866
Michael G Minter Samuel Snowberger (Seal)
Emanuel Stover George Specht (Seal)
 Henry Bauman (Seal)
 John Burger (Seal)
 Henry Ritter (Seal)

Franklin County SS
 Before me a justice of the peace, in and for
said County, personally came, Saml Snowberger George Specht, Henry
Bauman, John Burger and Henry Ritter, and in due form of
law, acknowledged the foregoing release, to be their act and deed
to the intent that the same might be recorded as such
 Witness my hand and Seal this
 Sixth day of April A.D 1866
 Emanuel Stover (Seal)

This extremely rare letter advises the consignment of $1,000 from the estate of Charles Hoch to the monastic society at Snow Hill in Quincy Township. Snow Hill was the site of a branch of the Ephrata Cloisters, a settlement of German Seventh-Day Baptists. Snow Hill consisted of a monastic society and people of the community that attended the church. The property of Snow Hill—about 130 acres—included a stone church, a dormitory, a mill, and shop buildings. The signatures on the document are witnessed and dated April 6, 1866.

52

This early-1900s image shows the infirmary located at South Mountain. The South Mountain Camp Sanitarium, founded by doctor and forester Joseph Rothrock, treated tuberculosis and was located on the grounds of Mont Alto State Park. By the standards of the day, the isolation and the fresh air made South Mountain a good location to treat tuberculosis patients. South Mountain also treated soldiers who had been exposed to mustard gas in World War I and later treated people with mental retardation.

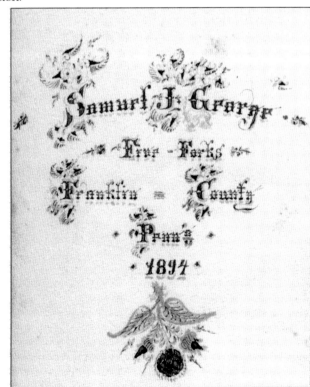

This 1894 bookplate, designed for Samuel J. George of Five Forks, is an outstanding piece of artwork. Around this time Five Forks, formerly called Mount Hope and situated on the Chambersburg and Waynesboro Road, was a small post office village with a gristmill, store, and blacksmith shop.

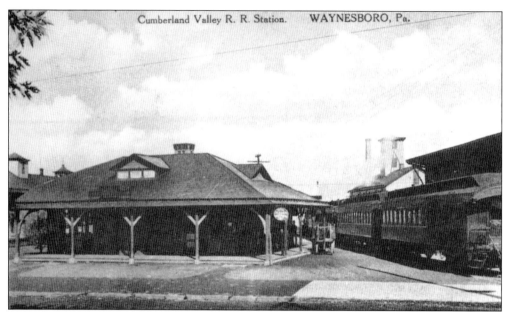

This view shows the Cumberland Valley Railroad station in Waynesboro in the early 1900s. The Mont Alto branch of the Cumberland Valley connected to Waynesboro, which was also served by the Western Maryland Railroad.

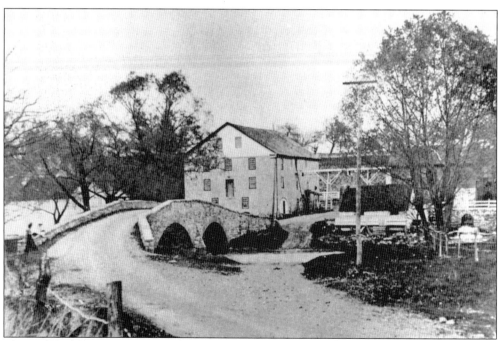

The scene is a classic view of Welty's Mill and Bridge in 1900. The mill dates back to around 1749. Along with the mill, a cooperage and distillery operated on the property. Welty's Bridge, which stands today, was built in 1856 by D. S. Stoner. The stone arch bridge is 137 feet long and 13 feet wide.

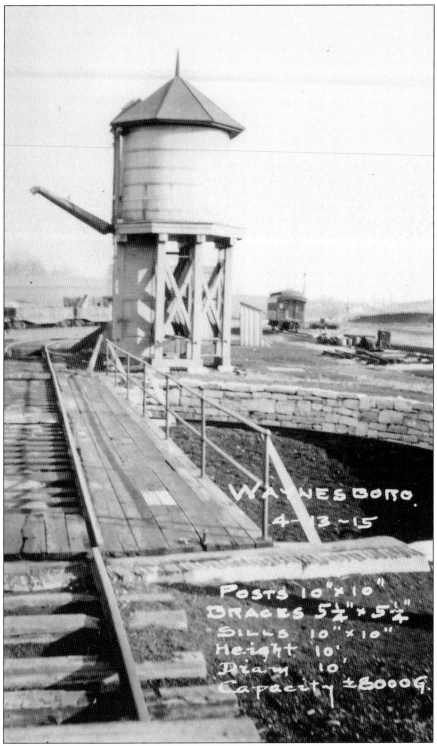

WAYNESBORO.
4-13-15

POSTS 10"x10"
BRACES 5¼"x5¼"
SILLS 10"x10"
Height 10'
Diam 10'
Capacity ±8000G.

This April 14, 1915, photograph shows the Cumberland Valley Railroad turntable and water tank in Waynesboro. In the distance are passenger and freight cars.

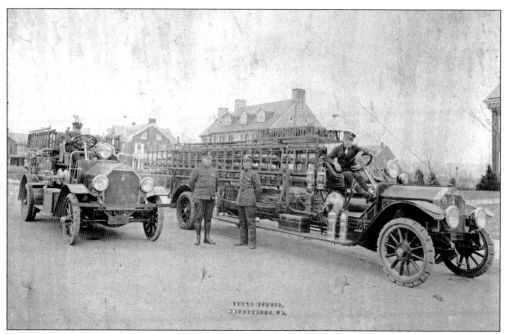

The Waynesboro Fire Department proudly displays its firefighting equipment. On the right is the 1918 Seagrave combination chemical truck used by the Mechanics Fire Company. On the left is the Always There Hook and Ladder Company with its 1916 American LaFrance city service truck.

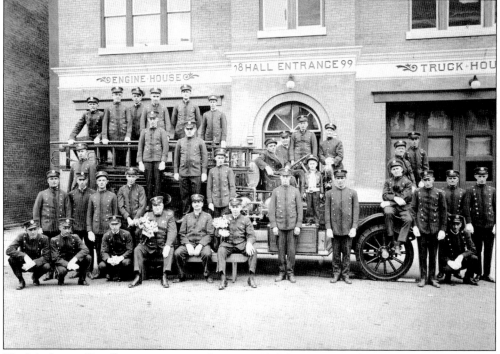

The Mechanics Fire Company poses with its new 1918 Seagrave combination chemical truck in front of the firemen's hall on South Potomac Street in Waynesboro.

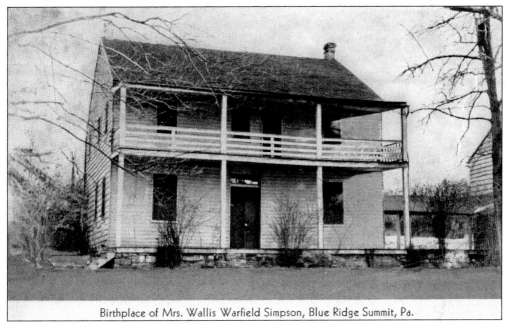

Birthplace of Mrs. Wallis Warfield Simpson, Blue Ridge Summit, Pa.

This house in Blue Ridge Summit is the 1896 birthplace of Bessie Wallis Warfield, who was later known as Mrs. Wallis Warfield Simpson and became the Duchess of York after marrying the former king of England. She met the Prince of Wales when still married to her second husband but ultimately divorced her husband to pursue a relationship with the Prince of Wales, who ascended to the British throne as Edward VIII after his father's death. Edward abdicated and married Wallis Warfield Simpson, who folklore says stopped using Bessie because too many cows had been given the name.

The New Franklin Fire Company displays its 1937 Ward LaFrance fire engine at a parade in Chambersburg in the 1960s. This firefighting apparatus originally belonged to the Cumberland Valley Hose Company of Shippensburg.

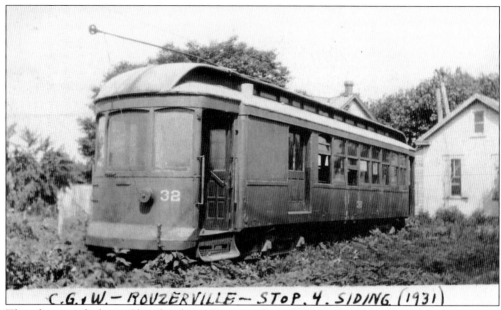

C.G.&W. – ROUZERVILLE – STOP. 4. SIDING (1931)

This photograph shows Chambersburg, Greencastle and Waynesboro combination car No. 32 at the four-siding stop in Rouzerville in 1931.

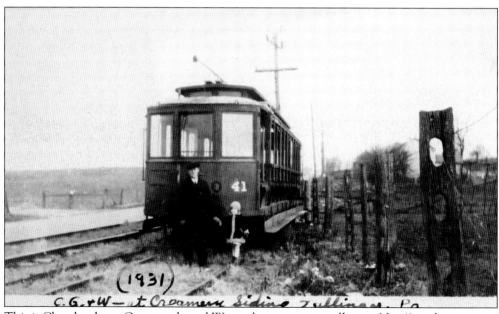

(1931)
C.G.&W. – at Creamery Siding Zullinger. Pa

This is Chambersburg, Greencastle and Waynesboro summer trolley car No. 41 at the creamery siding in Zullinger in 1931.

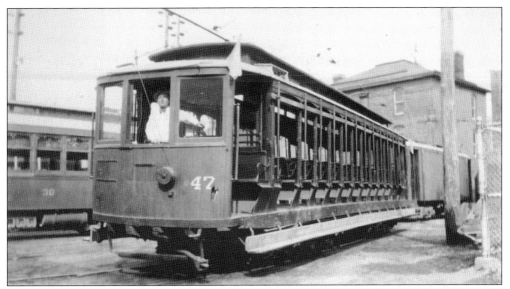

Shown is Chambersburg, Greencastle and Waynesboro summer trolley car No. 47 at the Waynesboro carbarn in 1931.

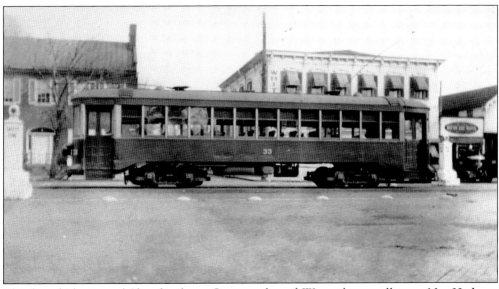

This broadside view of Chambersburg, Greencastle and Waynesboro trolley car No. 33 shows the trolley as it stops at center square in Waynesboro in 1930.

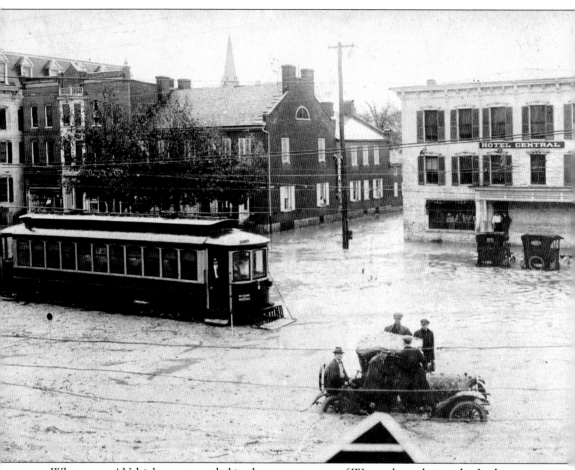

What a mess! Vehicles are stranded in the center square of Waynesboro during this hailstorm on June 6, 1917. Chambersburg, Greencastle and Waynesboro trolley car No. 35 and the automobiles are stopped by the sudden storm.

Five

MERCERSBURG AND COUNTRYSIDE

James Black built a mill at the site of present-day Mercersburg in 1730 about three miles from North Mountain. The town became known as Black's Town and was a trading place of Native Americans and early frontiersmen. In 1759, James Black sold his land to William Smith, who was a justice of the peace and operated a number of businesses. The town was then known as Squire Smith's Town.

In 1786, William Smith Jr. laid out the town with three north–south streets (Main, Fayette, and Park) and three east–west streets (Seminary, California, and Oregon). The town was renamed Mercersburg to honor Hugh Mercer, a doctor and brigadier general in the Revolutionary War.

During the course of the French and Indian War, attacks by Native Americans increased, and private and provincial forts were built along the frontier for protection. Although the war ended in 1764, the king of England forbade trade with the Native Americans until a more peaceful environment prevailed.

Some traders did not adhere to the order. Settlers were particularly concerned with the trade of firearms and ammunition because the weapons were being used against frontiersmen. To put a stop to the dangerous trading, a group of men called the "Black Boys," led by James Smith, a former captive of the Caughnawaga Indians, surprised the traders by confiscating and burning the goods. The traders returned to the British Fort Loudoun, seeking the capture of Smith and the Black Boys for their actions. Smith and the Black Boys clashed with British troops, but the conflict was resolved. Within a few months, the British abandoned Fort Loudoun.

The 15th president of the United States, James Buchanan, was born near Mercersburg at Cove Gap in 1791. As a boy, he lived in Mercersburg and worked in the family store. During his presidency, the issue of balancing slave and free states teetered next to the possibility of civil war. The election of Abraham Lincoln provided an answer to the uncertainty. The South seceded from the Union. Civil war came to America, and Mercersburg experienced the hardships of war and its price to humanity.

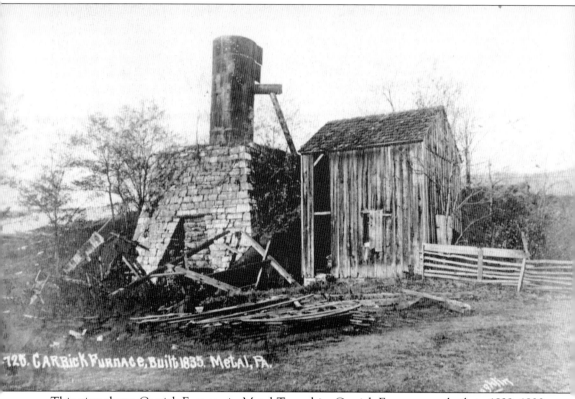

This view shows Carrick Furnace in Metal Township. Carrick Furnace was built in 1829–1830 and closed in 1844 because of declining business. It is likely that Carrick Forge was built before Carrick Furnace to support the work generated by the Mount Pleasant Iron Works, the original ironworks of Franklin County built in 1783 by the Chambers family.

This scene shows an early-20th-century winter day on Main Street in Concord. The Tuscarora Mountains appear in the background. Concord was laid out by James Widney, and lots were sold in 1791. The area took its name from Concord, Massachusetts.

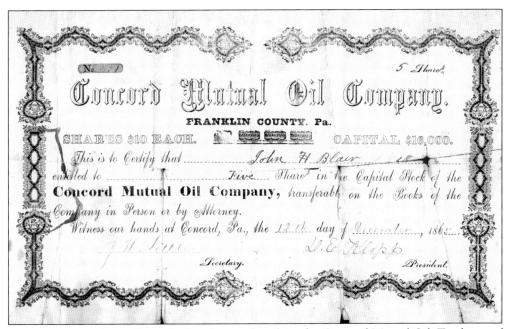

This is a rare stock certificate for five shares of stock in the Concord Mutual Oil. Total cost of the shares was $50, and the certificate was issued to John H. Blair on December 12, 1865. The company never grew.

DR. H. G. CHRITZMAN,

Physician and Surgeon,

Welsh Run, Pa., / 25 1888

Hon. John Stewart
 Dr Sir

 When I was
in Chamb'g. I heard it as
a matter of rumor that Mr
Gehr would in all probability
~~would~~ announce for Congress
I did not get an opportunity
to speak to Gehr and in that
was disappointed. Do you
imagine that his candidacy
will in any measure annull
my Senatorial Bu,? It looks
that way to me. Or "Vice Versa"
I dont disire to beat the air
in this Senatorial affair, but it
strikes me that we can honestly

This image is the first page of a letter written by Dr. H. G. Chritzman, a physician and surgeon in Welsh Run, to Hon. John Stewart in Chambersburg. The letter is dated January 25, 1888.

64

claim it as a question of rotation

Have acquired some little information from Antrim Twp: which might be valuable to you, but prefer to give it orally.

Did I understand you correctly that the Pres: of the C.V.R.R. had the granting of its courtesy to me under advisement?

Let this be "Inter Nos"

Would be pleased to hear from you at your earliest convenience relative the effect of Lehrs announcement Truly yours

H. G. Chritzman

The second page of the Chritzman letter to Stewart is shown. The letter discusses political interests of the day. Chritzman was a former president of the Franklin County Medical Society and was elected to the state legislature in 1884. Stewart was an attorney, educated at Princeton, and politically active in the state, serving as a state elector in several national elections, and he was an independent Republican candidate for Pennsylvania governor in 1882.

A fine view of the hotel at Cove Gap, with the Tuscarora Mountains in the background, was taken in the late 1880s. The old stone structure still stands at Cove Gap and when built was along the public road from Warren Township. It now stands along Route 16.

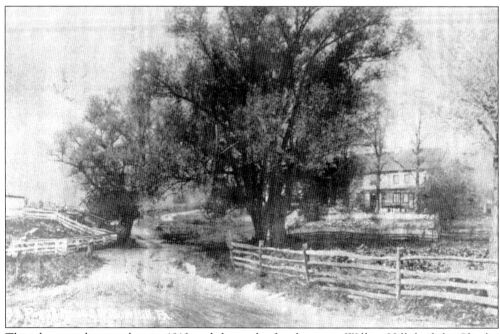

This photograph was taken in 1910 and shows the first house in Willow Hill, built by Charles Fleming in 1878.

To garner men to fight for the Union in the Civil War, Pres. Abraham Lincoln authorized the first national draft in the Enrollment Act of 1863. Adult males, age 20 to 45, were eligible for the draft, but a drafted man could pay a $300 commutation fee or provide a substitute to serve in his place. Shown is a "certificate of exemption on account of having furnished a substitute." This certificate provided Jacob Rummel of Montgomery Township exemption on February 27, 1865. The draft was only instituted in districts that had not met the quota of volunteers.

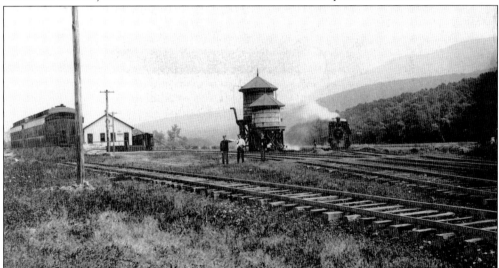

This is the Cumberland Valley Railroad at Richmond Furnace in the late 1890s, showing the steam engine passing the water tanks and heading to hook up to the passenger cars. The strong production of iron ore at Richmond Furnace brought the railroad, and the town is named for the president of the ironworks, Richmond L. Jones. The furnace at Richmond was built in 1865 at the site of the first Franklin County furnace operation—Mount Pleasant Iron Works. All the structures in the foreground of the photograph have been removed.

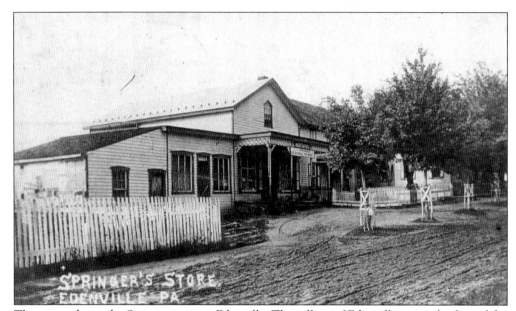

This scene shows the Springer store in Edenville. The village of Edenville sits at the foot of the mountain ridge of Parnell's Knob.

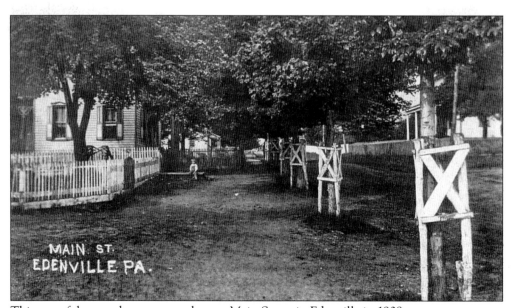

This peaceful scene shows a young boy on Main Street in Edenville in 1908.

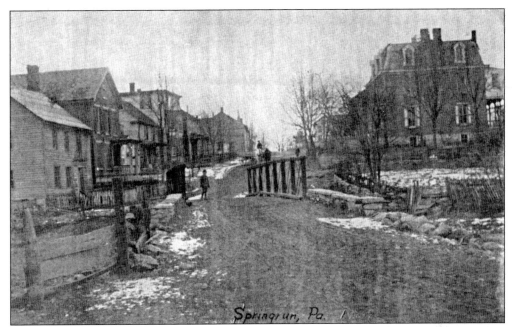

This is Main Street in Spring Run in 1908. The small area depicted was settled in 1768. Like many of the early villages settled in Franklin County, the settlement grew around a church congregation.

The post office, stores, and residences along Main Street in Fannettsburg are shown in 1909. Fannettsburg was laid out in lots and sold in 1792. As an agricultural community, the town had a distillery. Without sufficient roads to transfer the grain, frontier farmers would ferment the grain and make a drinkable alcohol beverage, like rye whiskey, for sale or trade. Needless to say, when the new U.S. government placed a tax on distilled spirits to help pay for the debts of the Revolutionary War, local farmers were not pleased. Such displeasure was shared by farmers in western Pennsylvania where farmers fired shots at government officials trying to register a still. This 1794 event became known as the Whiskey Rebellion and required Pres. George Washington to gather a militia to enforce the laws of the newly formed United States.

→FROM←
=Wm. S. McALLEN=:-
STOCK FARM.

Fannettsburg, Pa, _____ Jan 18 1888

Dr Sir: Frank Elliott inform'd
me to-day, that they as Administrators
of Margaret, Beatty's, estate; thought
of making a disbursement of the
moneys & funds on hand some day
next week, as there has been no
Guardian appointed for my four
children, whose ages areas follows:
12, 15, 17, 19, years. What I wish to
know immediately is: (If I send
you the name of the person they
wish appointed as their guardian)
if the Judge can confirm the)
appointee this week?
Are you still of opinion "That
the Judge would refuse to
appoint my daughter, guardian?
(my eldest daughter who is over
the age of 21.) over —

Shown is a letter from William S. McAllen, dated January 18, 1888, who owned a stock farm in Fannettsburg. He is inquiring who will be appointed guardian to four children, whose parent or guardian, Margaret Beatty, has passed away.

70

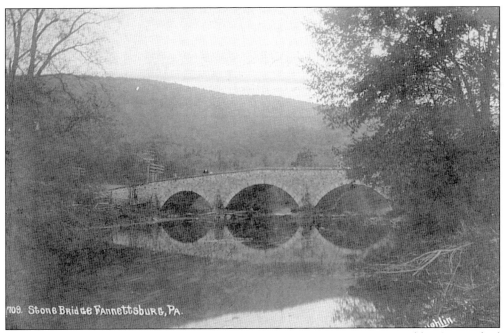

The old stone arch bridge at Fannettsburg is shown in 1911. At one time, Franklin County had 23 stone arch bridges.

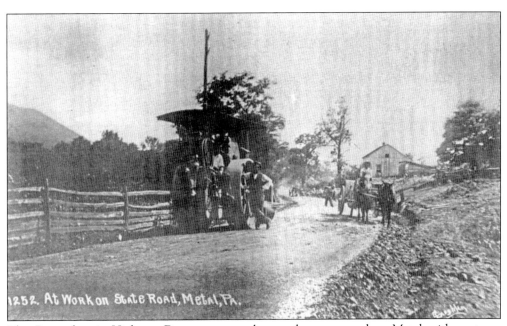

The Pennsylvania Highway Department works on the state road at Metal with a steam road roller.

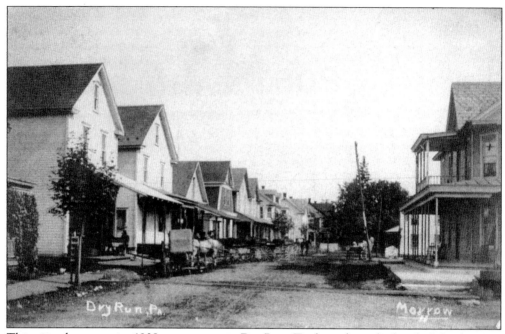

This view shows a quiet 1908 street scene in Dry Run. To the right is the hotel of the day. Dry Run was founded in 1838 and originally called Morrowstown.

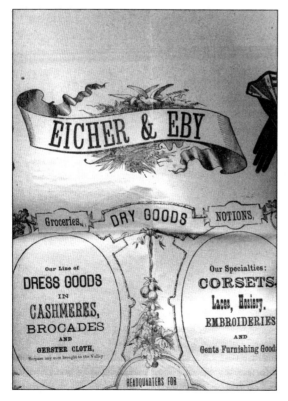

Eicher and Eby, located in Dry Run, used this wrapping paper to package customers' purchases and promote the store's products. Eicher and Eby sold fabrics, notions, groceries, and various vessels for cooking and storage.

72

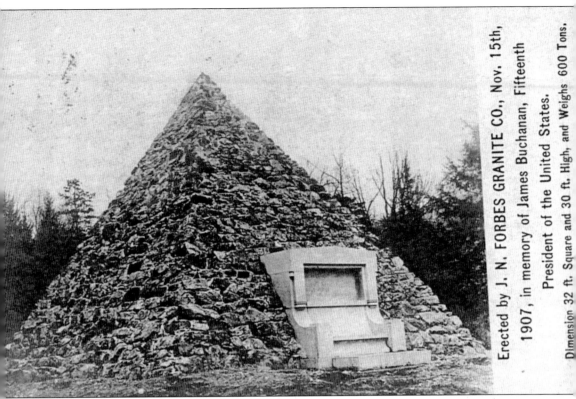

Erected by J. N. FORBES GRANITE CO., Nov. 15th, 1907, in memory of James Buchanan, Fifteenth President of the United States. Dimension 32 ft. Square and 30 ft. High, and Weighs 600 Tons.

Pictured is the 600-ton stone pyramid monument to 15th U.S. president James Buchanan. Harriet Lane Johnston, Buchanan's niece and White House hostess during his presidency, willed $100,000 for creation of a monument in Washington, D.C., and Stony Batter, the birthplace of Buchanan. The Baltimore architectural firm of Wyatt and Nolting designed this monument—a pyramid that is 38 feet square and 31 feet high and is composed of rubble and mortar from the area of Buchanan's birth. It was erected at Stony Batter on November 15, 1907, by J. N. Forbes Granite Company. It remains today and is the centerpiece of Buchanan State Park, off Route 75.

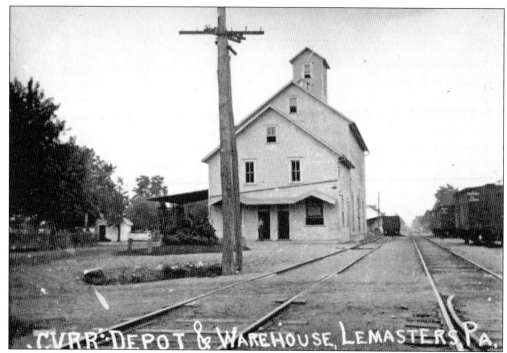

This is the Cumberland Valley Railroad station and warehouse in 1908 at Lemasters in Peters Township. The structure still stands today.

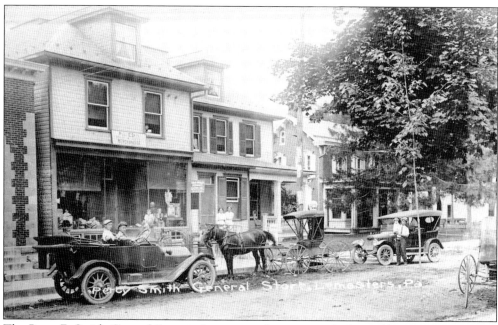

The Percy E. Smith General Store in Lemasters, shown around 1911, sold a variety of general merchandise, including gasoline for automobiles.

A Cumberland Valley Railroad passenger train is just leaving the station at Lemasters in 1909 with a head of steam. The village of Lemasters grew around the 11-acre parcel of land that Samuel Plumb purchased in 1876.

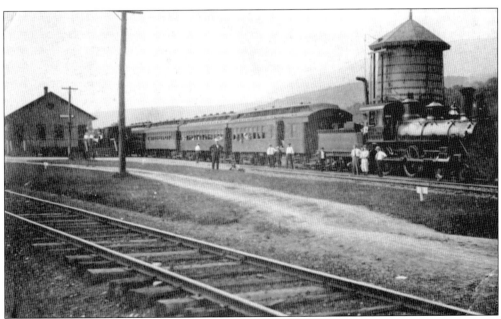

A Cumberland Valley Railroad passenger train and crew stand next to the water tower at Richmond Furnace in 1908.

Doylesburg,
June 16th 1875

T. B. Kennedy Esq

My Dear Sir I drop you a
note to let you know I still are
on the land of living and are
as lame as ever I thought sure
the wether settel I would get
better of the lamness but it seem
not it woried me out and be
me out is thair likeley to be
an opening and a chance fo
me on your R R That I would
be able to earn something in
the main time mutch obliged
to you for your kindess towar
me let me hear from you
soon I ordered 25 lb of wire
from Miller & Co Carlisle and
got a bill of it shipped the
1 st of June it ware ordered to
be shipped to Richmond Pa

Pictured is a letter written by W. F. Morrow of Doylesburg to T. B. Kennedy, president of the Cumberland Valley Railroad. Morrow, who was injured while employed by the railroad, is seeking reemployment with the railroad. The letter is dated June 16, 1875. Kennedy moved to Chambersburg as a boy, was educated at the Chambersburg Academy, and attended Marshall College in Mercersburg, graduating with honors. He was a practicing attorney before becoming president of the Cumberland Valley Railroad.

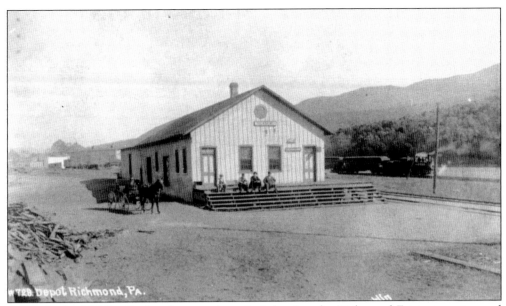

A Cumberland Valley Railroad passenger train is leaving the Richmond Furnace station and heading to Mercersburg in 1909.

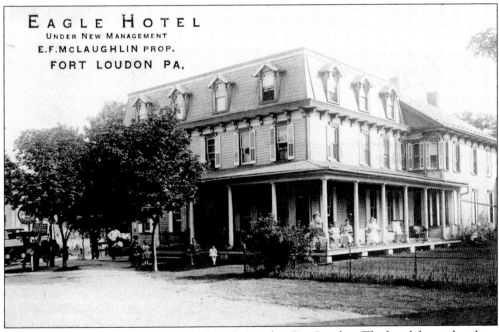

EAGLE HOTEL
UNDER NEW MANAGEMENT
E.F.McLAUGHLIN PROP.
FORT LOUDON PA,

This photographic promotion shows the Eagle Hotel in Fort Loudon. The hotel, located midway between Philadelphia and Pittsburgh, is a long-standing and favorable departure point. The owner is listed as E. F. McLaughlin.

FORT LOUDON, PA.,

(The site is about a mile east of the town of Loudon) was erected in 1765 as a protection for the settlements in the valley from incursions of the Indians and many were the stirring scenes enacted there in Provincial times. The fort was frequently garr'soned by British as well as by Provincial troops and before wagon roads were built over the mountains, it was a great point of departure for packhorse trains for Bedford, Fort Cumberland and Pittsburgh. A sign points the way to the site of the old fort.

EAGLE HOTEL

C. W. McCLAIN, Proprietor

On the Lincoln Highway, about midway between Pittsburgh and Philadelphia

Beautiful Scenery. Fine Accomodations.

Another photographic promotion of the Eagle Hotel in Fort Loudon tells the history of the location. The proprietor listed is C. W. McClain. This property was the birthplace of Thomas A. Scott, who was president of the Pennsylvania Railroad system from 1874 to 1881.

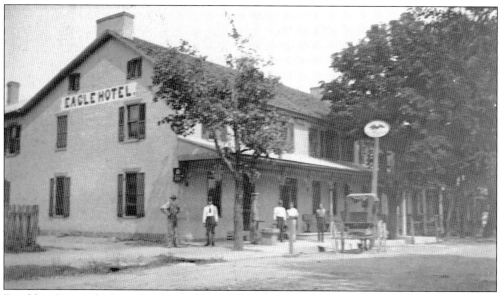

Franklin County had another Eagle Hotel. This photograph shows the Eagle Hotel located in Upper Strasburg. Upper Strasburg was founded in 1789 and was the first settlement of Germans in Franklin County that was concentrated enough to lay out a town.

An advertisement of the Path Valley Bank in Dry Run shows the officers and directors of the day. The bank was established in 1908.

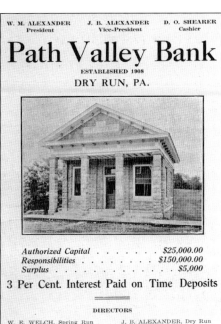

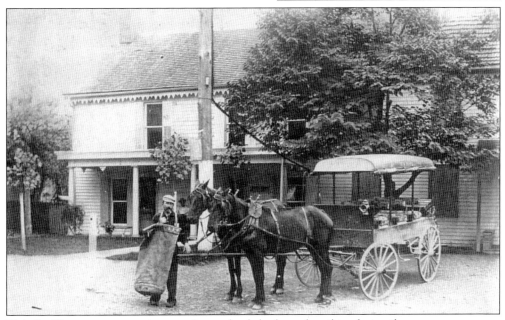

This St. Thomas postman is preparing to load the bag of mail in the mail wagon to transport it to the Chambersburg post office. The photograph was taken in the early 1900s. Franklin County had no post offices until six years after it was formed as a county. Official government business came by courier; otherwise, letter delivery was informal and by whatever means citizens could arrange independently.

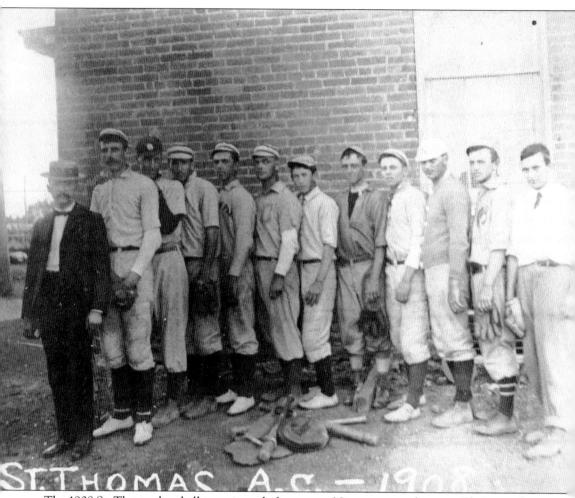

The 1908 St. Thomas baseball team is ready for a game. Nineteen years later, on Christmas day, baseball great Nellie Fox, the Gold Glove–winning second baseman of the Chicago White Sox, was born in St. Thomas.

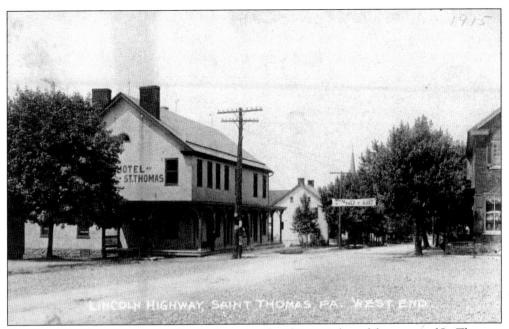

The Hotel St. Thomas is pictured in the foreground of this 1910 shot of the square of St. Thomas. The view looks west to what will become part of the Lincoln Highway, the first transcontinental highway, which was formed in 1913. In Pennsylvania, the Lincoln Highway connected existing roads and turnpikes, such as Forbes Road and the Chambersburg and Bedford Turnpike.

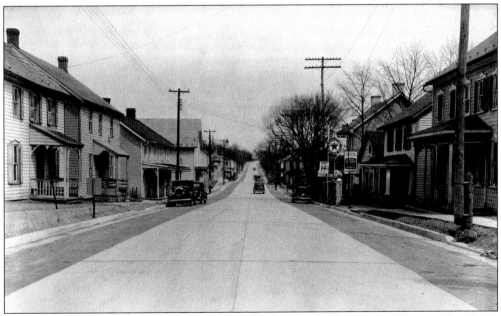

This 1930s photograph of St. Thomas shows the Lincoln Highway after it was widened. St. Thomas was originally named Campbellstown after the first settler, George Campbell, who came to the area around 1734. Later, in 1790, Thomas Campbell laid out the town. Since another Campbellstown existed, the town was renamed to honor Thomas Campbell by adding *St.* to his first name.

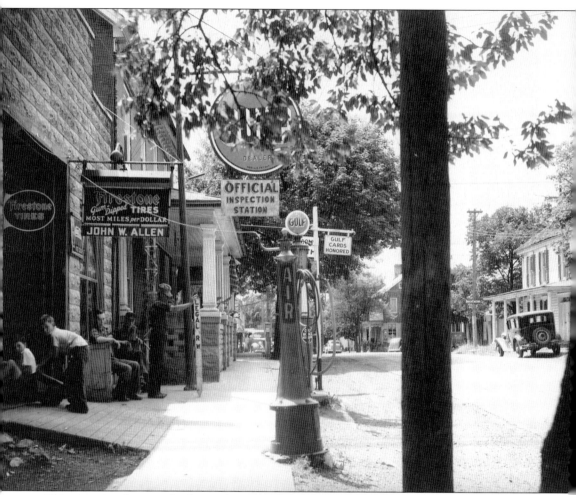

This vintage photograph shows the portion of the Lincoln Highway that passes through St. Thomas before the widening. Note the gentleman on the left of the photograph with the Legal RW (right of way) post.

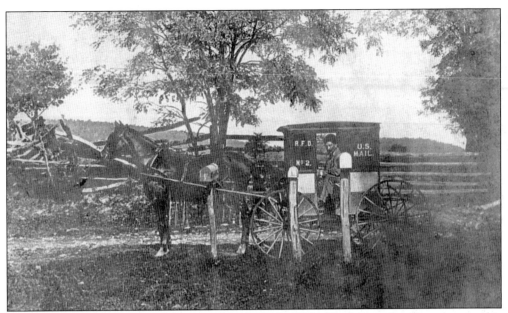

The Mercersburg mail wagon delivers mail in the early 1900s. The Mercersburg area was not this quiet during the Civil War. Confederate troops led by J. E. B. Stuart on October 10, 1862, took horses and hostages. One of the hostages taken on that day was Perry A. Rice, postmaster of Mercersburg. Unable to escape or be part of a prisoner exchange, Rice was sent to Libby Prison in Richmond, Virginia, where he died before being released.

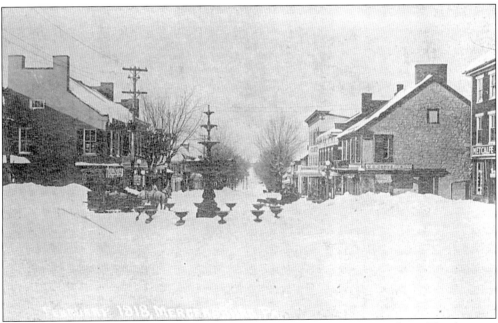

This 1918 snow scene shows the lovely fountain on the square of Mercersburg. The fountain exists today but has been removed from the square.

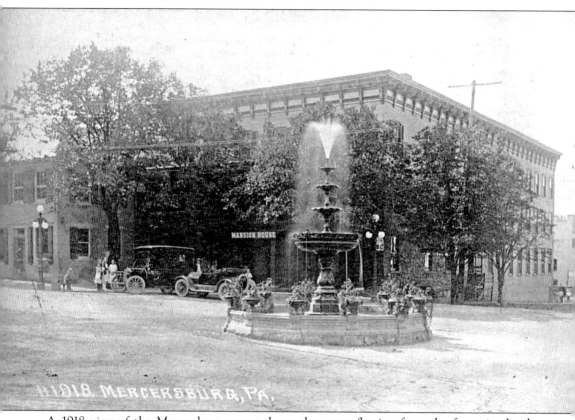

A 1918 view of the Mercersburg square shows the water flowing from the fountain. In the background on the southwest corner of the square is the Mansion House. The Mansion House was the site of an 1852 James Buchanan speech. Buchanan moved to Mercersburg as a boy and helped in his family business on Main Street.

Six

FAYETTEVILLE
AND BEYOND

Edward Crawford, another Scotch-Irish immigrant, gained the rights to 640 acres south of Fayetteville in 1740 and developed a farming estate. Locally the area was known as Penn's Manor. As the road connected the area of Black's Gap, or Greenwood, on the old Chambersburg and Gettysburg turnpike to the borough of Chambersburg, settlement increased. David Eby built several dwellings and a sawmill in 1810, and the area became known as Milton's Mill. A school was built in 1824. In 1826, Benjamin and Jacob Darby purchased the settlement from the Chambersburg Bank and laid out the town. The settlement applied for a post office, and the town was renamed Fayetteville after Marie-Joseph-Paul-Yves-Roch-Gilbert du Motier, Marquis de Lafayette, who was inspired by the Declaration of Independence and came to America to volunteer his service to Gen. George Washington.

East of Fayetteville was the area of Caledonia. Today Caledonia is best known for the state park that spills from Franklin County into Adams County. However, in the 19th century, the abundance of limestone and timber in South Mountain made it a natural location for an iron ore furnace.

Thaddeus Stevens—a lawyer in Gettysburg and Lancaster who became a noted abolitionist, anti-Mason, and champion of education—began the Caledonia Iron Works in 1837. Caledonia was named for the county of Stevens's birth in Vermont. In retaliation for Stevens's outspoken opposition to the causes of the South, Confederate soldiers—under orders of Gen. Jubal Early—burned the Caledonia Iron Works and all the company buildings and vandalized the workers' cabins in June 1863. The destruction was so zealous that as Gen. Robert E. Lee moved east toward Gettysburg on July 1, 1863, he directed that the workers and their families be supplied from his personal commissary.

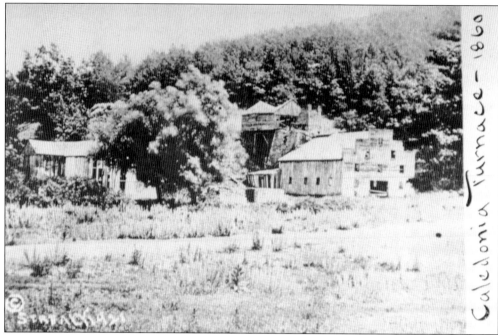

Caledonia Furnace – 1860

This view shows the Caledonia Iron Works before Confederates burned the complex on June 26, 1863. The ironworks, owned by Thaddeus Stevens, did not reopen before Stevens died in 1868.

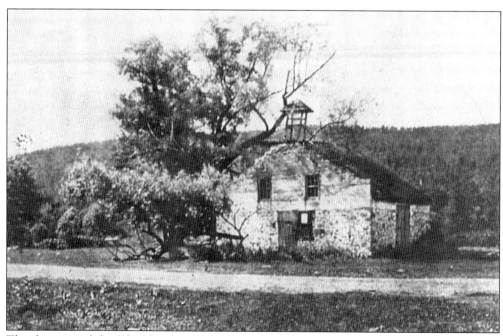

The disrepair of the Thaddeus Stevens blacksmith shop is evident in this 1890 photograph. After Stevens's death, the land passed through several owners. In 1902, Pennsylvania purchased the land. The Chambersburg and Gettysburg Trolley Company leased the land, built a trolley line to the park, added amusements, and used the blacksmith shop as a station.

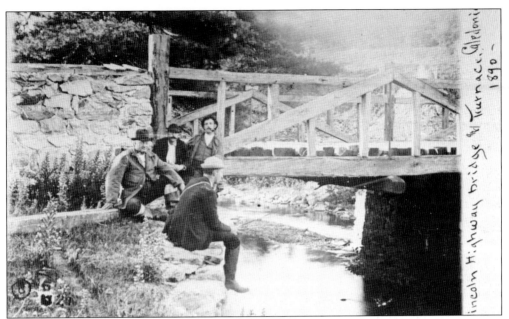

Three men relax and fish by the wooden bridge at Caledonia along the Lincoln Highway in this 1890 photograph.

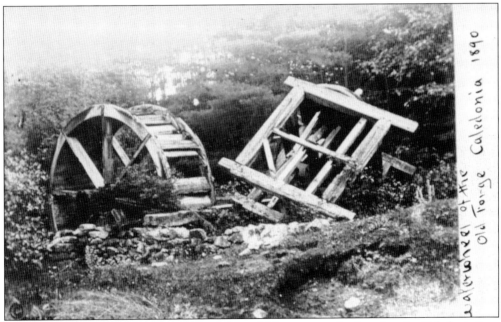

This 1890 photograph shows the remains of the old forge waterwheel used at the Caledonia Iron Works. Typically the waterwheel powered the bellows to reheat the pig iron so the blacksmith could hammer out excess carbon and yield wrought iron.

The poor condition of the Caledonia stables is evident in this 1890s shot. In addition to the iron-production buildings, the ironworks complex included a village area with cabins, a company store, and buildings to house horses and other livestock.

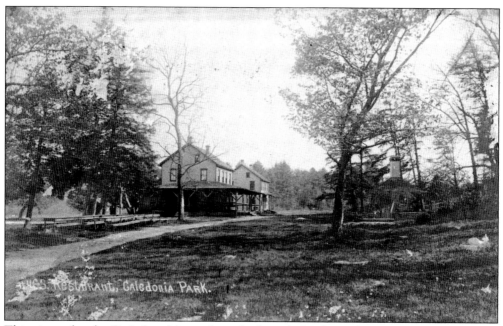

This view, taken by C. A. Laughlin, is from the Lincoln Highway, facing the Hotel Caledonia and Restaurant in 1907.

This is a menu card for the correspondents' dinner at the Hotel Caledonia for a Chambersburg newspaper called the *People's Register* on September 12, 1908. The menu includes April-born fried chicken, potatoes in pulp form, apples squeezed fine, and burning coffee.

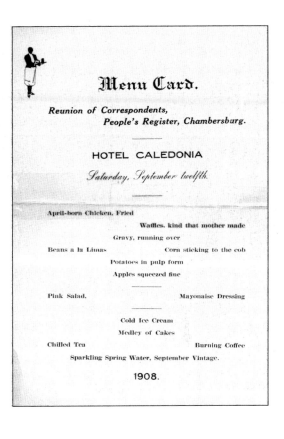

Menu Card.

Reunion of Correspondents,
People's Register, Chambersburg.

HOTEL CALEDONIA

Saturday, September twelfth.

April-born Chicken, Fried

Waffles, kind that mother made

Gravy, running over

Beans a la Limas Corn sticking to the cob

Potatoes in pulp form

Apples squeezed fine

Pink Salad, Mayonaise Dressing

Cold Ice Cream
Medley of Cakes

Chilled Tea Burning Coffee

Sparkling Spring Water, September Vintage.

1908.

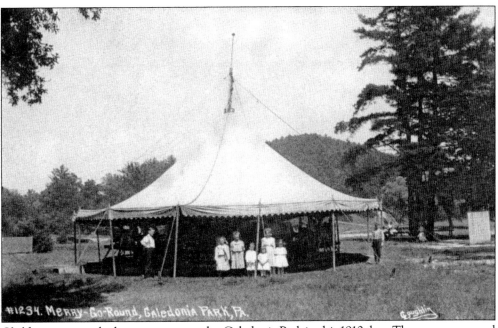

Children wait to ride the merry-go-round at Caledonia Park in this 1910 shot. The merry-go-round was located behind the trolley station, which was in the former blacksmith shop.

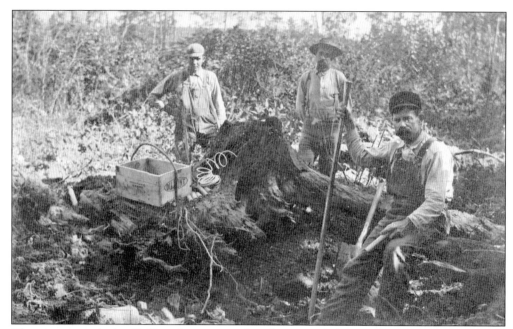

Three men are placing DuPont dynamite under a large tree stump in this photograph taken in 1908 at Pond Bank, known as a sand mining area.

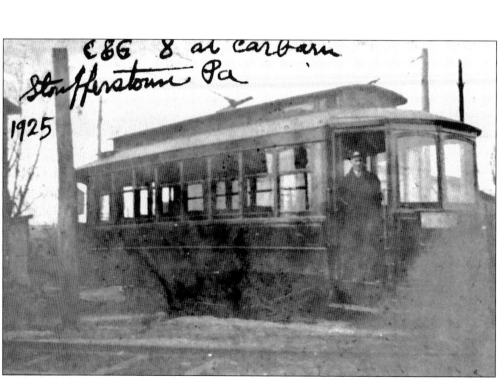

Chambersburg and Gettysburg Street Railway car No. 8 leaves the carbarn at Stoufferstown in 1925. The carbarn, if it existed today, would be at the southeast corner of Route 30 and Stouffer Avenue in Chambersburg. Calvin E. Senseney is the motorman.

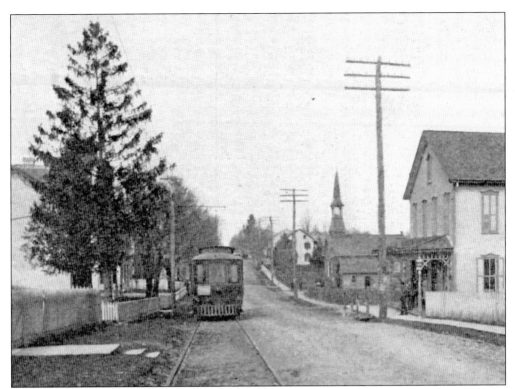

A Chambersburg and Gettysburg trolley car is making its way along Main Street in Fayetteville in 1909. Although this trolley line was originally intended to run to Gettysburg from Chambersburg, Caledonia was as far as the line extended.

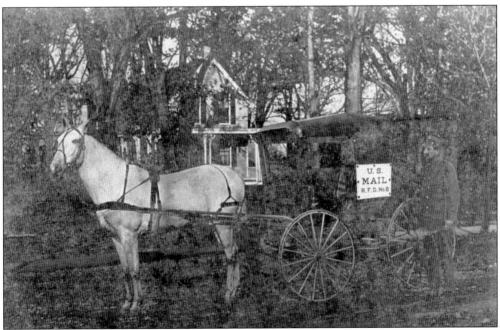

David H. Zarger, Fayetteville postman, delivers mail on Main Street in Fayetteville in 1908.

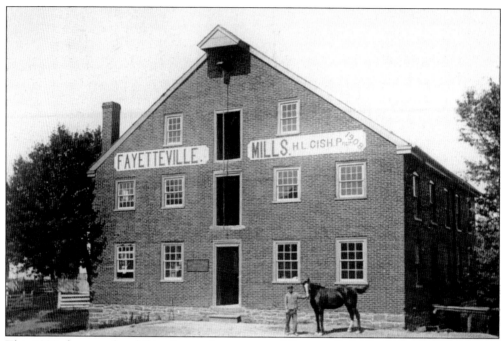

This 1908 photograph exhibits the newly constructed Fayetteville Mills. H. L. Gish owned the mill, which used the waterpower of the East Branch of the Conococheague Creek to operate the mill's waterwheel.

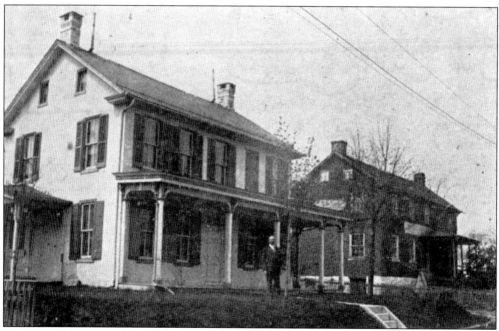

Dr. Alonzo Upperman Holland stands in front of his home in Fayetteville in 1905. He attended the Academy of Fayetteville, was educated in Baltimore, studied medicine with a Dr. Barrick of Maryland and Dr. Edgar Senseney of Chambersburg, and graduated from the medical college at Philadelphia in 1870. He immediately set up practice in Fayetteville.

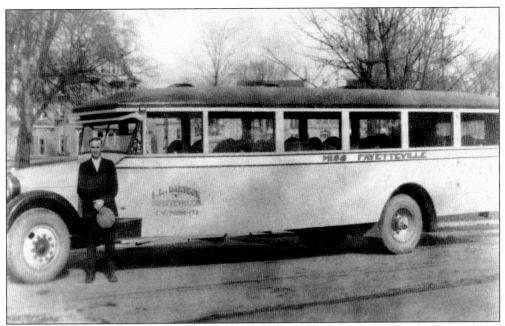

I. L. Hartzok stands beside his bus named *Miss Fayetteville* before picking up passengers bound to Chambersburg in this 1930s photograph. Note the trolley tracks in the foreground.

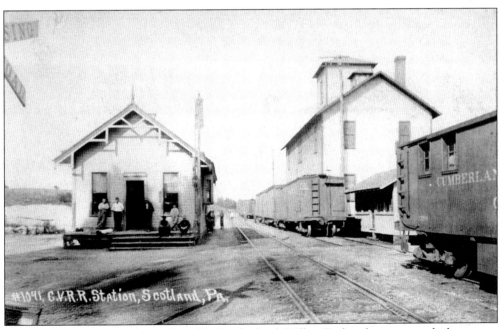

This 1907 photograph shows the old Cumberland Valley Railroad station and elevator at Scotland. To the right are a maintenance of way car and some freight cars. The Thomson family from Greenock, Scotland, settled in their country's namesake in Franklin County in 1792. A settlement in Caledonia County, Vermont, was planned, but 500 acres in the Kittatinny Valley were purchased instead.

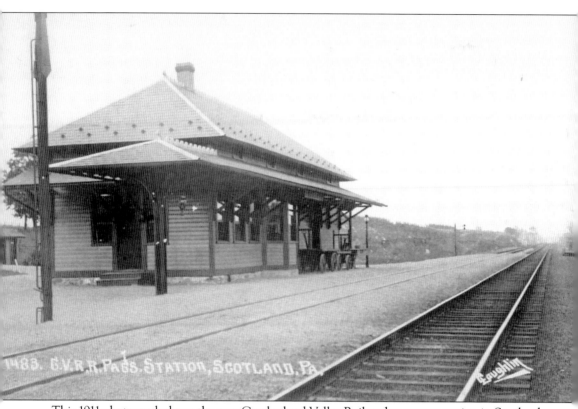

This 1911 photograph shows the new Cumberland Valley Railroad passenger station in Scotland.

Seven

AROUND AND ABOUT SHIPPENSBURG

The current town of Shippensburg is located in both Franklin and Cumberland Counties. The first settlers to the area in 1730 inhabited the area along the stream now known as Burd's Run. A settlement at the crossroads of King and Queen Streets of present-day Shippensburg developed, including the Widow Piper's Tavern. The tavern, built by Samuel Perry in 1735, also served as the Cumberland County courthouse for a brief period in 1750 and 1751 when Shippensburg functioned as the county seat of Cumberland.

Edward Shippen acquired the rights to a large tract of land from the Penn family in 1737. The town is named for Shippen. His daughter Sarah married James Burd, and the couple came west to Shippensburg in 1752 to lay out the town before James's service in the French and Indian War. By 1784, when the state was planning to create a new county, Shippensburg, Chambersburg, and Greencastle were locations considered as the county seat. With Chambersburg chosen by the legislature, Shippensburg remained in Cumberland County. The growth of the next century expanded the town into the boundaries of Franklin County.

Roxbury, an original settlement of Lurgan Township, was first settled by the Pomeroy family and later laid out by William Leephar in 1778. It was well trafficked by traders and packhorses. A gristmill was built in 1783, a forge in 1798, and the Roxbury Furnace in 1815.

Orrstown, founded by John and William Orr in 1833, was originally called Southampton. When the town was presented for incorporation as a borough, another Southampton existed, so it was renamed Orrstown in 1847. The population was about 400 at the time it was incorporated, nearly twice the current population.

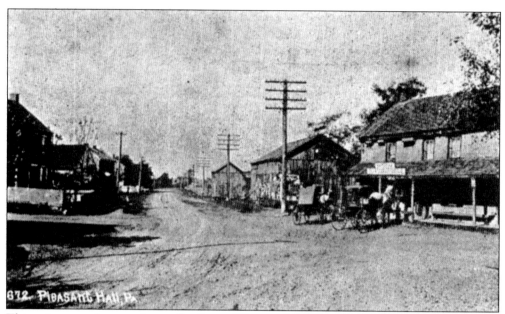

This quiet scene features the small village of Pleasant Hall in 1910.

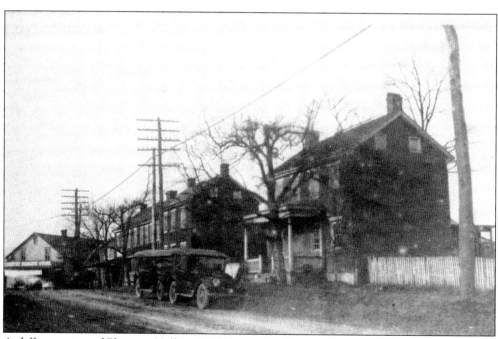

A different view of Pleasant Hall in 1915 shows the Country Bargain Store on the square. It appears in the lower left of the photograph.

Pictured is an early log cabin, located at the old forge near Roxbury. The Sound Well Forge was built in 1798 and the Roxbury Furnace in 1815. Roxbury is on the Condoguinet Creek and at the base of Kittatinny Mountain. This photograph was taken in 1910.

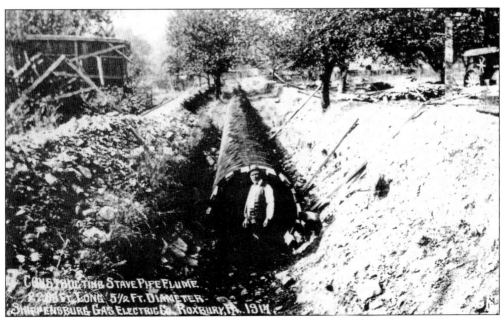

These construction workers are installing a wooden-stave pipe flume for the Shippensburg Gas and Electric Company in Roxbury in 1917. The dimensions are 2,288 feet long with a 5.5-foot diameter.

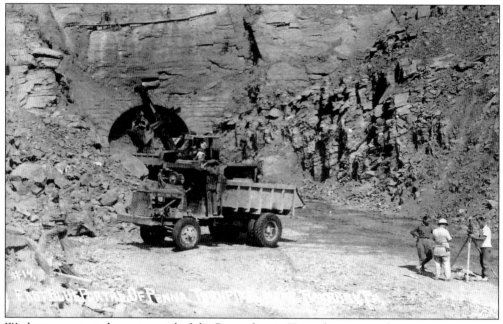
Workers construct the east portal of the Pennsylvania Turnpike near Roxbury in 1937.

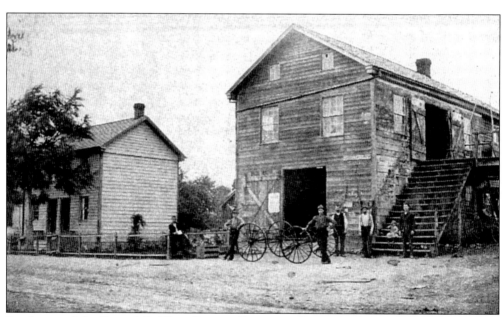
Employees of the Samuel B. Wise Carriage Factory in Orrstown show off the carriages they made in the late 1880s. The product must have been a good one because the business grew from just two employees in 1870.

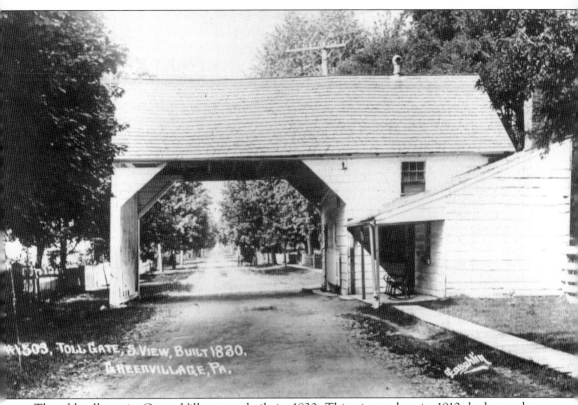

The old tollgate in Green Village was built in 1830. This view, taken in 1910, looks south toward Chambersburg.

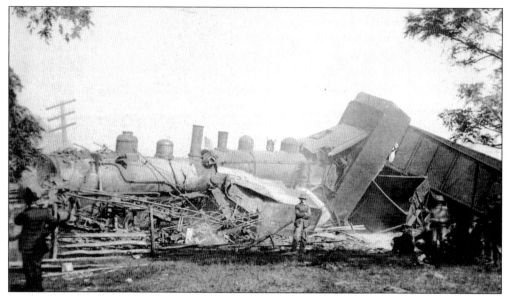

One Western Maryland Railroad passenger train and one Western Maryland freight train collided in this disastrous train accident at Pinola in 1912. The photographer was Anson Goodhart of Shippensburg.

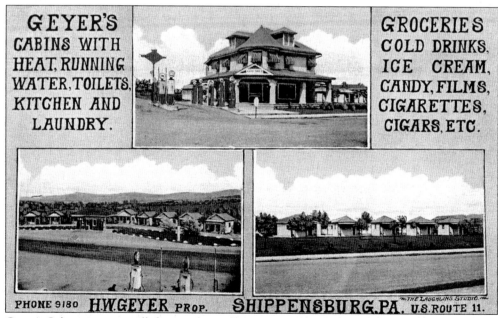

Geyer's Cabins promotes all the comforts of home in this advertisement and uses the excellent photography of C. A. Laughlin. Geyer's Cabins was on Route 11, just south of Shippensburg. The site is now an automobile sales business.

Chambersburg and Shippensburg Street Railway car No. 20 is heading east on West King Street in Shippensburg in 1915. It is approaching the Cumberland County line.

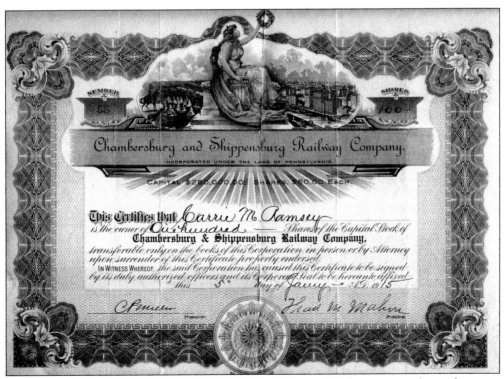

This image is a Chambersburg and Shippensburg Street Railway Company stock certificate.

This view is of the former Sunset Airways at the Chambersburg Airport near Culbertson in the 1940s. Jay Sollenberger leased and operated the business.

Eight

ALL ABOARD
FRANKLIN COUNTY'S
TROLLEYS AND TRAINS

Franklin County's trains and trolleys served businesses and residents of the community, bridging the distance between friends and family and bringing Franklin County products to key cities of America's east coast. Trolleys shortened the time from one end of town to the other and bridged villages, carrying passengers to work and recreation.

The Cumberland Valley Railroad, one of the oldest railroads in America, first opened for travel to Chambersburg in 1837. It connected Chambersburg to Harrisburg and provided access to the network of waterways associated with the Susquehanna River.

During the Civil War, Franklin County's rail was a mixed blessing. It aided the Union in disbursing troops and supplies, yet it attracted the Confederates to destroy the mode of transportation and pillage the stores in adjoining warehouses. The Cumberland Valley Railroad upgraded and expanded the railroad after the Civil War. New iron and steel rails were laid on new limestone beds. Wooden bridges were replaced with iron ones. New depots were built at major stops, and stations were constructed in rural communities.

With the thriving iron ore industry in Franklin County, branch railroad lines were connecting to the Cumberland Valley Railroad. The Mont Alto Railroad Company and the Southern Pennsylvania Iron and Rail Road Company are examples. The steel industry and competing railroads attempted to reduce the cost of transporting products on the Cumberland Valley Railroad and Pennsylvania Railroad by building another rail line, the Southern Pennsylvania Railroad, to connect to the Reading Railroad in Harrisburg for shipment to Pittsburgh. The project started in 1883 and continued for two years, but it was abandoned because of the cost. Nine tunnels were partially bored and 120 miles of bed were graded. Following the abandonment of the project, the Cumberland Valley Railroad acquired the right-of-way. Nearly 50 years later, the partially completed project was sold to the state and became the Pennsylvania Turnpike.

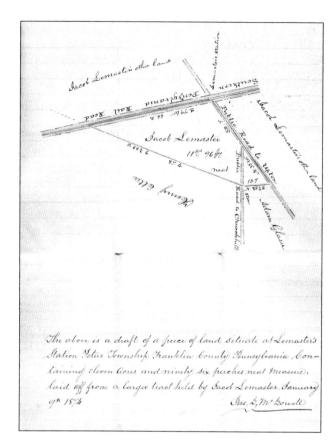

This shows a land draft of the Southern Pennsylvania Railroad right-of-way, the location of the station, and the surrounding property that was owned by Jacob Lemasters in Lemasters on January 9, 1874.

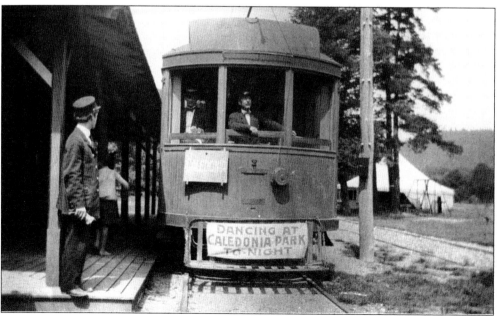

Chambersburg and Gettysburg trolley car No. 12 is at the Caledonia station in 1910 preparing to take passengers to Fayetteville. The merry-go-round is to the right.

This is a stock certificate from the former Southern Pennsylvania Iron and Rail Road Company, which had its offices in Reading and had an operating line at Richmond Furnace in 1872. Shortly thereafter, the Southern Pennsylvania Iron and Rail Road Company changed ownership to the Southern Pennsylvania Railroad Company, which owned the Cumberland Valley Railroad.

This image shows an 1874 freight bill of lading for the Cumberland Valley Railroad at the Loudon station. The old station in Fort Loudon has been preserved and remains today.

Form 60 D. 1-1-'98

Cumberland Valley Railroad Company.

R. B. RITCHEY,
Freight and Ticket Agent

Office of Station Agent,

Mercersburg, Pa. Feb 25.─ 1899

G M Smith Esq
 Waynesboro Pa
Dear Sir

 Yours of the 24th recvd I will be at home on Thursday and Friday next as far as I know I dont suppose you will be able to do anything with the Council untill it reorganizes which will not be for several weeks yet Dr D S Brook is Burgess C H Fuller D W Faust Ezra Brubaker J S Rhea W S Hostetter W S Wolff C C Scully I would hardly suppose you could get the present President of Council to call a special so late in his last year

(Yours truly
 R B Ritchey.

This letter is from R. B. Ritchey, the freight and ticket agent for the Cumberland Valley Railroad at Mercersburg, to Smith Manufacturing in Waynesboro. The letter is dated February 25, 1899. Ritchey appears to be inquiring about a special meeting.

THE C. G. & W. STREET RAILWAY COMPANY
MANAGEMENT OF
THE POTOMAC EDISON COMPANY

March 8th 1927

C.E.Senseny:---

 To-night on your arrival at Chambersburg
11-30 P.M you will return to Marion and await the arrival
 of Special car from Waynesboro Vick & Bitner
 take their car which will be 32 and return to
 Chambersburg with the Lodge fellows.
 Nothing to collect.

 They will return with your car to Waynesboro
 D.E.McK

This Chambersburg, Greencastle and Waynesboro Street Railway Company notification tells motorman Calvin E. Senseney of his special instructions for his March 8, 1927, shift.

106

Moorehead C. Kennedy entertains guests at his estate on Ragged Edge. The celebration in October 1925 honors the employees of the Cumberland Valley Railroad. The Cumberland Valley Railroad was absorbed into the Pennsylvania Railroad in 1919.

This photograph shows Moorehead C. Kennedy with esteemed dignitaries of the Cumberland Valley Railroad in October 1925.

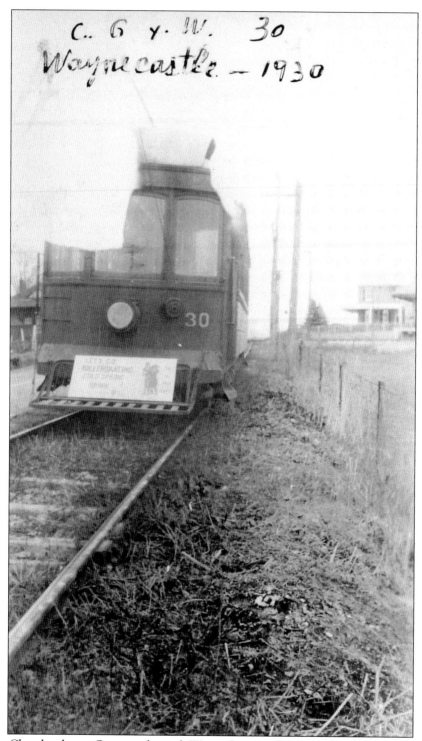

This is Chambersburg, Greencastle and Waynesboro trolley car No. 30 passing through Waynecastle on Route 16 in 1930 and heading toward Waynesboro. The sign on the cowcatcher says, "Let's go rollerskating Cold Spring rink."

Nine

BUSINESS AND INDUSTRY

By the time Franklin County had rebuilt after the Civil War, a diversity of businesses operated in Franklin County. Farming remained the number-one industry. As the area rebuilt and grew, the need for laborers skilled in the building trades increased. Tradesmen like carpenters, masons, and furniture makers could make a living in any community in the county. Factors like proximity to transportation and natural resources contributed to the kinds and locations of businesses. Mills needed to be close to waterpower. Ironworks needed sufficient and easy access to timber, limestone, and water. The railroad was a large employer in the county.

As time passed, methods of production changed. Steam power gave way to electricity, and some businesses could not shoulder the expense of change. Agriculture was strong throughout the community, so businesses and industries that supported agriculture remained. Retail stores and pharmacies changed with the times.

Throughout Franklin County's history, it has been a transportation center. The good location attracted a variety of businesses, and although the dominant mode of transportation changed through time, Franklin County's appeal did not. Large industrial employers were present in Waynesboro when the rest of Franklin County consisted of a larger number of small employers and sole proprietors. Two of the longest-operating large industrial employers in Franklin County are T. B. Wood's, Inc., and the Frick Company.

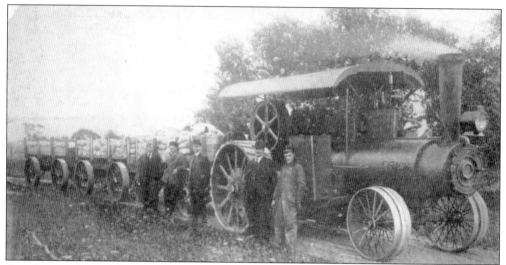

An advertisement of the Frick Company, from around 1910, shows the traction engines with the new protected cleat on the larger rear wheels to prevent damage to the road.

FRICK & CO.S. "ECLIPSE" TRACTION OUT-PULLS ALL COMPETITORS COMBINED.

An 1884 advertisement highlights the powerful Eclipse traction engine made by the Frick Company in Waynesboro. It is promoted as an outstanding engine that beats all the competition.

J. MONTGOMERY, M. D. P. B. MONTGOMERY, M. D.

Chambersburg, Pa., Oct 30th 189 7.

Mrs Harriet Rummel

To **J. MONTGOMERY & SON,** Dr.

147 EAST MARKET STREET.

To Professional Services from Jun 21th 97 to Jun 26. 97 $ 6. 2t

Credits, $ ———

Office Hours: { Until 9 A. M. { 12 to 2 P. M. { After 7 P. M. Amount due *Ths Mill* . $ 6. 2

Received Payment, *from*

The items of this account can be seen at the office. Please bring this Statement with you. J. Montgomery + Son

This receipt was issued on October 30, 1897, by Dr. J. Montgomery of the medical practice J. Montgomery and Son, located at 147 East Market Street in Chambersburg. Market Street is now Lincoln Way.

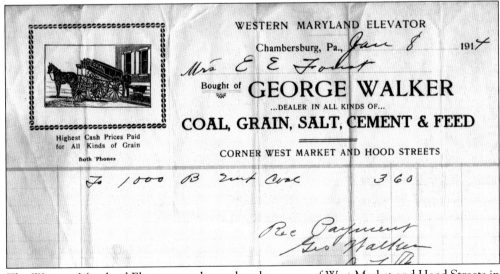

WESTERN MARYLAND ELEVATOR

Chambersburg, Pa., Jan 8 191 4

Mrs E E Foslet

Bought of **GEORGE WALKER**

...DEALER IN ALL KINDS OF...

COAL, GRAIN, SALT, CEMENT & FEED

Highest Cash Prices Paid for All Kinds of Grain

Both 'Phones

CORNER WEST MARKET AND HOOD STREETS

To 1000 lb 2unt Coal 3 60

Rec Payment
Geo Walker

The Western Maryland Elevator was located at the corner of West Market and Hood Streets in Chambersburg and owned by George Walker in 1914.

CHAS. L. HANEY.

Fine Commercial Job Printing
... of every description ...
.... executed with
. Neatness and Dispatch .
..... Our Prices
.. are always the lowest ..
.... consistent with
... First - class Work ...
... GEO. W. KLIPPERT ...

+ CHAMBERSBURG, PA., *Mar. 3* 1890.

C. V. Hose Co.

Co. HANEY & KLIPPERT, Dr.

Ebersole's Building, West Market Street, _____

_____ *Opposite Western Maryland R. R. Depot.*

· · · PROMPT · SETTLEMENTS · ARE · REQUESTED. · · ·

Feb.	21	To 75 Ribbon Badges	$3	50
"	21	" 100 Oyster Tickets		
"	21	" 200 Ice Cream "	1	50

Matt Bitner
Manager Recd payment
 Haney & Klippert

A receipt from Haney and Klipper verifies that Cumberland Valley Hose Company No. 5 purchased ribbon badges, tickets, and ice cream on March 3, 1890.

Chambersburg, Pa. Mar. 3ᵈ 1890

Mr. C. V. Hose Co.

To J. R. KERR & BRO, Dr.

JOB PRINTERS.

No. 353 EAST MARKET STREET.

1890

Feb.	10	2500	Tickets for Oil Stove & Type Writer	$5	25
"	11	1000	" " Cornet	2	00
"	13	1000	" " Chamber Set	2	00
"	20	1000	" Admission	2	00
"	26	1000	" Hanging Lamp	2	00
				$13	25

This receipt was issued to the Cumberland Valley Hose Company No. 5 by J. R. Kerr and Brothers Printers, located at 353 East Market Street in Chambersburg, for printing services in March 1890.

The Cumberland Valley Railroad provided a receipt to A. M. Funk for the purchase of 11 feet of white pine lumber in September 1891.

T. B. Wood and Company gave Ralph King this receipt for repairing mill parts. It was issued on May 31, 1879.

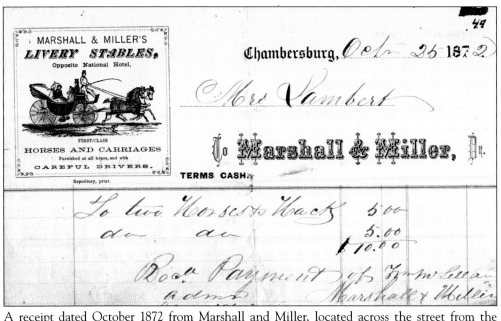

A receipt dated October 1872 from Marshall and Miller, located across the street from the National Hotel in Chambersburg, offers horses and carriages as well as drivers.

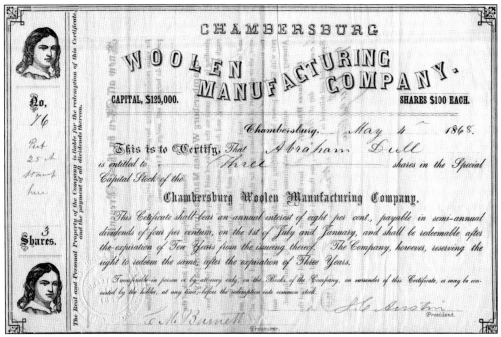

This stock certificate was issued to Abraham Dull from the Chambersburg Woolen Manufacturing Company in 1868. The shares sold for $100. Chambersburg Woolen Manufacturing Company was started in 1866.

B. R. SUMMER,

CARPETS, FURNITURE, ROOFING, FENCING

Quincy, Pa., Dec 5 1908,

Mr Ellis E Foust,
 Chambersburg. Pa,
Dear sir;— I wish to arrange
with you to have afternoon
Conference with you and
Mr Metcalfe some time
after the middle of coming week
at the Shop. Perhaps we can
arrange by Phone—

This 1908 letter from B. R. Summer requests a meeting with Ellis E. Foust. B. R. Summer sold carpets, furniture, fencing, and roofing.

C. F. FENDRICK

DEALER IN

GRAIN, SEEDS, FLOUR, MILL FEED, PHOSPHATE, COAL, PLASTER, SALT, ETC.

MERCERSBURG, PA. Mch 18 1915.

Mrs E E Foust—
 I enclose you ck
For 212 bus Wheat @ 150 = 318-
I dont think I will to feed wheat
at 1.50 —

 Yours
 C F Fendrick

C. F. Fendrick of Mercersburg sent this receipt with a check for 212 bushels of wheat to Mrs. Ellis E. Foust.

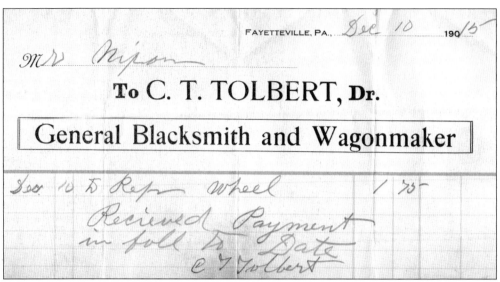

FAYETTEVILLE, PA., *Dec 10* 190*15*

Mr Nixon

To C. T. TOLBERT, Dr.

General Blacksmith and Wagonmaker

Dec 10 To Repr wheel | *1 | 75*

Recieved Payment in foll to Date

C T Tolbert

This receipt is from C. T. Tolbert of Fayetteville, a blacksmith and wagonmaker. C. T. Tolbert repaired a wagon wheel for a Mr. Nixon in 1915.

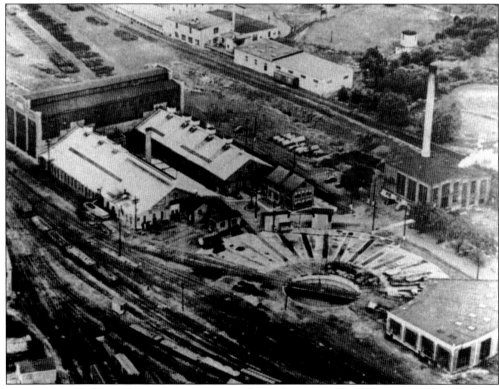

An aerial view shows the roundhouse and railroad shops on Grant Street in Chambersburg. The railroad was vital to the Franklin County business community. It expanded access to marketplaces and was a main employer of Franklin County.

The Letterkenny Army Depot was established in 1942 and for many years was the largest employer in Franklin County, bringing high-quality jobs and support to local businesses. All along the way, Letterkenny remained a strong contributor to U.S. defense. This October 1961 photograph shows participants in the Letterkenny tour, sponsored by the Chambersburg Chamber of Commerce. Pictured in the front row from left to right are chamber president Bill Coffield, Maj. Howard Reffner, 1st Lt. Barclay Wellman, and Col. Harvey Holt.

H. C. Gabler was started by Harold C. Gabler in 1936 and was incorporated in 1956. Shortly after incorporation, Harold was joined by his two sons, Harold C. Gabler Jr. and Tom Gabler. Over the years, two grandsons joined the business—Harold "Chip" Gabler and Ben Gabler. The three-generation business has consistently given excellent service.

Ten

TRADING CARDS AND COMMUNICATION

After the Civil War, a new color printing process became popular and affordable. It was chromolithography, and it mimicked the look of oil painting. Large runs of beautifully colored trading cards could be produced affordably to spread the marketing word. The cards were so attractive that many households kept an album of trading cards in the parlor.

Not all trading cards were in full-color. Some were simple with just the name, address, and product. Trading cards identify businesses that are long forgotten, provide information to re-create a town's former layout, and recall what a business sold or did. Franklin County's merchants and vendors offer a nice variety.

J. A. Shoemaker of Amberson Valley advertises Diamond Dyes in this trading card from the late 1800s.

This envelope, postmarked August 11, 1908, was mailed to B. C. Snyder from the Lemasters Warehouse Company with just a name and city.

S. J. Hafer advertises a public sale of livestock and farm implements on January 23, 1907.

A late-1800s trading card from the Strock Ramsey Store in St. Thomas advertises Dr. Jaynes Tonic.

This trading card is for Horseshoe Tobacco sold by J. H. Eachus in Greencastle in the late 1800s.

C. A. Martin and Brother in St. Thomas used this trading card to advertise Willimantic Thread.

C. H. Fallon of Mercersburg advertises the Household Sewing Machine Company in this 1900 trading card.

The White Sewing Machine Company advertises on this trading card given by J. W. Fallon of Mercersburg in the early 1900s.

PUBLIC SALE
Of Personal Property.

Thursday, Mar. 10, 1898.

4 HEAD OF
HORSES

No. 1, is a dapple gray mare, 6 years old, works wherever hitched; No. 2, is an iron gray mare, coming 4 years old, a good off-side worker and single driver; No. 3. is a sorrel horse, coming 4 years old, works well under the saddle; No. 4, is a dark brown mare, coming 5 years old, and is a good off-side worker.

10 HEAD OF
CATTLE!

6 of which are milch cows that will be fresh at time of sale; two fall cows, 1 heifer, will be fresh by the time of sale; 3 bulls, 1 a well-bred shorthorn; ELEVEN HEAD OF

Shropshire and Southdown Sheep,
all nice ewes with lamb;

56 HEAD OF HOGS

17 of which are brood sows, and 5 will have pigs before sale; the balance will have pigs later in March and April; 1 Poland boar, 38 head of shoats, will weigh from 40 to 100 pounds; one 4-horse wagon and bed,

1 Osborne Binder,

in good order; 2 Osborne mowers, in good running order; 1 good buggy pole, 1 set of breechbands, 2 sets front gears, 1 set of single harness, 4 blind bridles, and a few other articles not necessary to mention.

Sale to commence at 10 o'clock, a. m., sharp, on the above named day, when terms will be made known and a credit of 12 months will be given on all sums of $5 and upwards, by

MARTIN G. BRICKER.

PEOPLE'S REGISTER Print.

A broadside promotes an upcoming public sale by auctioneer J. Hafer near Scotland on March 10, 1898. This advertisement was printed in Chambersburg by a local newspaper, the *People's Register*.

The St. Thomas Social Club gave this
handmade program at the Washington's
Birthday Dance on February 23, 1912.

This trading card is a promotion of the Bride
Heater that was sold by George W. Steiger in
Mercersburg, around 1900.

The Quincy Orphanage created this trolley car safety advertisement in the early 1900s.

This trading card is from the J. W. Rearick store in Chambersburg around 1900.

George W. Steiger, of Mercersburg, advertises the sewing machines of the Household Sewing Machine Company in this trading card of the early 1900s.

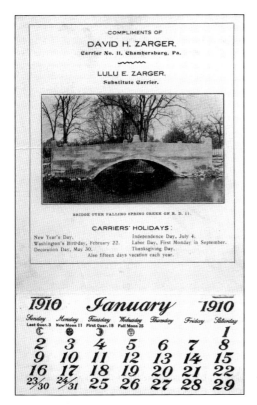

This 1910 advertising calendar was given by postman David H. Zarger. It tells the days when mail is not delivered and identifies his wife, Lulu, as the substitute carrier.

ACROSS AMERICA, PEOPLE ARE DISCOVERING SOMETHING WONDERFUL. THEIR HERITAGE.

Arcadia Publishing is the leading local history publisher in the United States. With more than 3,000 titles in print and hundreds of new titles released every year, Arcadia has extensive specialized experience chronicling the history of communities and celebrating America's hidden stories, bringing to life the people, places, and events from the past. To discover the history of other communities across the nation, please visit:

www.arcadiapublishing.com

Customized search tools allow you to find regional history books about the town where you grew up, the cities where your friends and family live, the town where your parents met, or even that retirement spot you've been dreaming about.